IMAGES
of America

CLEARWATER'S
HARBOR OAKS

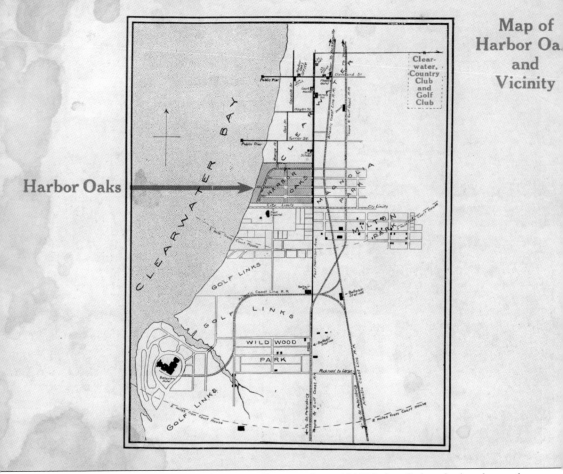

Harbor Oaks →

This detailed map of Harbor Oaks, originally printed in a 1916 Harbor Oaks sales brochure, places the neighborhood in both Clearwater and in the surrounding area, which was sparsely populated at the time. Note the size of both Wildwood Park and the notation "rock road to Largo," now a major city adjacent to Clearwater. Also, the railroad depicted led to the nearby Hotel Belleview grounds. (Courtesy of Frank Hibbard.)

ON THE COVER: This photograph, taken in 1945, is of the Plunkett/Alvord home, completed in 1932. This Mediterranean-style structure features several examples of elegant detailing, including the use of quoins, ornate entrance architraves, stone and marble reliefs, and the incorporation of large terraces. It sits 23 feet above sea level and overlooks a lawn that slopes down to the waters of Clearwater Bay. Today, the property appears identical as it did when it was built except for a swimming pool and landscaping enhancements. (Courtesy of the Tampa-Hillsborough County Public Library System—Burgert Bros. Collection.)

IMAGES
of America

CLEARWATER'S
HARBOR OAKS

Tom Adamich and Gary Dworkin, MD
Foreword by James Anthony Schnur
Introduction by Michael L. Sanders

ARCADIA
PUBLISHING

Published by Arcadia Publishing
Charleston, South Carolina

Printed in the United States of America

Library of Congress Control Number: 2013935776

For all general information, please contact Arcadia Publishing:
Telephone 843-853-2070
Fax 843-853-0044
E-mail sales@arcadiapublishing.com
For customer service and orders:
Toll-Free 1-888-313-2665

Visit us on the Internet at www.arcadiapublishing.com

To the memory of Dean and Donald Alvord, whose vision for neighborhood development and governance made Harbor Oaks the community it is today; also, to the dedicated homeowners past, present, and future who will continue to maintain the vitality that symbolizes Harbor Oaks and its people.

CONTENTS

FOREWORD

Pinellas County celebrated its centennial of independence from Hillsborough County in 1912. Within the same period that Clearwater became the seat for this new county, one of the earliest areas of settlement found new life as Dean Alvord transformed the lands south of the downtown and toward Belleair into his lavish Harbor Oaks development. Notable residents came to this area in the early-to-mid-20th century, taking residence in prominent homes along the bluffs adjacent to Clearwater Bay.

In capturing the history of Harbor Oaks, authors Tom Adamich and Gary Dworkin, MD, remind us that it too celebrates a centennial as its significance to Pinellas County history began more than 15 years before Alvord's birth. In 1841, at a time when the entire Pinellas peninsula had fewer than 200 residents, Fort Harrison took shape as an outpost during the Second Seminole War (1835–1842). By the early 1900s, as Alvord's business acumen brought him to Florida, the neighborhood of small wooden homes and "cracker" cottages began its transformation into a development that remains the city's signature historic district.

Similar to the rebirth of Clearwater's downtown that occurred after a fire in June 1910 destroyed much of the central business district, Alvord's design of Harbor Oaks during the 1910s reshaped this community. Long before Clearwater's municipal limits stretched eastward toward Tampa Bay or included suburban developments such as Countryside, Harbor Oaks established itself as a place where seasonal and year-round residents shaped the region's identity.

The authors provide a detailed and richly illustrated account of homes and history within Harbor Oaks. They also offer so much more, mentioning that Alvord's Japanese Gardens at Eagle's Nest became a popular roadside attraction during the 1930s and that many of the homes in Harbor Oaks have been occupied by notable residents long after the original owners have moved away or passed.

Through their research, Adamich and Dworkin remind us that history often begins at home. The impressive dwellings in this well-established area of Clearwater have important stories to tell, and this book recounts them with great detail and precision.

—Jim Schnur
Historian, Pinellas County Centennial (1912–2012)
Pinellas County Historical Society

ACKNOWLEDGMENTS

While we were blessed to have an abundance of historical resources and artifacts contributed by a significant number of helpful benefactors, several people deserve special commendation: Jim Schnur, Nancy Orth, Kenneth Weiss, Gyneth Stanley, Lamar MacNutt, Sandy Jamieson, Alan Dadetto, Bill Wallace, Frank and Teresa Hibbard, Cedio and Melba Saltarelli, Brenda and Ken Brown, Bill and Gail Ruggie, John and Trudy Cooper, Sophia Vasilaros, Lynn Flaster, Ernest Upmeyer, and David Hemerick, DDS. We also could not have accomplished this task in such a short time without the dedicated efforts of Clearwater historian Michael L. Sanders and photographer/photograph editor Karl Scheblein. It was their diligence and dedication to preserving the rich history of Clearwater (as represented via Harbor Oaks) that made the fruits of our labor possible.

Finally, the persons deserving the most recognition are the late Jan MacNutt, who led the major campaign to designate Harbor Oaks as a National Landmark in 1988, and Gary Dworkin, MD, whose passion for his home and for celebrating Harbor Oaks' history warrants accolades. In this day of individual isolationism (technology-driven or otherwise), Gary's community spirit should be recognized and held up as an excellent example of civic pride.

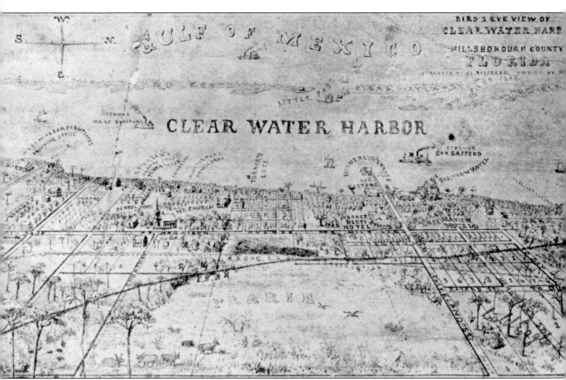

This bird's-eye-view map of Clear Water Harbor as it appeared in 1885 was published in a small history of Clearwater written by the Clearwater Woman's Club in 1917. The map was prepared by surveyor J.L. Rousseau and cartographer B.W. Maddak. (Courtesy of Michael L. Sanders.)

INTRODUCTION

Harbor Oaks was Clearwater's first planned residential development and, among other platitudes, was proclaimed "the finest shore development on the 'West Coast' [of Florida]" in early advertisements. It became the first historic district in Pinellas County in 1988 when it was placed in the National Register of Historic Places. Famous personages that have resided in Harbor Oaks include inventor Donald Roebling; members of the Ingersoll family; famous race car driver Nigel Mansel; author Rex Beach; Brooklyn Dodgers owner Charles Ebbets; and members of the Studebaker, Bucknell, and Procter families.

Years before the area known today as historic Harbor Oaks existed, however, history had already left its mark here. On April 2, 1841, during the Second Seminole Indian War, Fort Harrison began operations on the bluff overlooking Clearwater Harbor to serve as a convalescent post for soldiers from Fort Brooke at Tampa. It was named for the sixth president of the United States, William Henry Harrison. Abandoned after only six months, the garrison had placed Clearwater on the map as one of Florida's earliest health resorts. The soldiers, while here, took occasional excursions to the outlying islands and sampled some of the springwaters that arose in the bay and gave Clearwater its original name, Clear Water Harbor. Thus, these same soldiers became some of Clearwater's first tourists. An 1885 bird's-eye view of Clear Water Harbor by surveyor W.L. Rousseau (page 8) illustrates the site of Fort Harrison, which stood in the same location that Harbor Oaks would be developed many years later in 1914.

Clearwater was an isolated settlement in the 1880s, and access to the area was limited to schooners traveling from the Cedar Keys to points south and overland trails. A post office was established in 1858, and Russian Peter A. Demens brought his narrow gauge Orange Belt Railway through Clearwater in 1888. By 1891, Clearwater was incorporated, and the town included the area of today's Harbor Oaks. In short order, Clearwater was opened up to the citrus and farming industries' northern markets. Meanwhile, in 1910, events were beginning to take place in New York that would make Harbor Oaks a reality.

Dean Alvord, joined later by son Donald, had established himself as a first-rate developer in New York with subdivisions like Prospect Park South in Jamaica, Queens Borough; Belle Terre; and the Dean Alvord Estates on Long Island. In doing so, he rubbed shoulders with famous lawyers, financiers, and industrialists of the day. Quickly learning that the addition of amenities to basic platted land made marketing sense, he turned his focus to Florida, a dream fueled by the famous Henry Flagler, who sought his investment advice on Miami holdings.

This book celebrates the 100th anniversary of Alvord's dream—the dream of developing Harbor Oaks into a winter haven for wealthy northerners of the day.

Prepared under the knowledgeable direction of noted cardiovascular surgeon Gary H. Dworkin, MD (who resides in the John M. Studebaker III house), and master librarian Tom Adamich (who has previously written articles about Harbor Oaks for *Tampa Bay History*), *Clearwater's Harbor Oaks* is a testament to Dean Alvord's vision and the dedication of the homeowners who have

lived there to maintain and enjoy its beauty. That Harbor Oaks has managed to survive 100 years in Pinellas—the smallest, yet most densely populated county in Florida—is no small miracle in itself.

No book about Harbor Oaks would be complete without mentioning the Remig and Saltarelli families. Howard T. Remig, father of Melba Saltarelli, was an early trustee of Harbor Oaks from 1952 to 1963. A plaque in the community states that Remig "sought to maintain and preserve the ambience, integrity and unique single family residential character of historic Harbor Oaks." Taking up the mantle from his father-in-law, Cedio Saltarelli fought to carry this mission forward for many years. Over time, many others contributed to the Harbor Oaks preservation efforts as well. Due to space limitations, it is not possible to mention all those individuals who have contributed to Harbor Oaks' longevity and character.

It is my hope that this remarkable new book will become a true resource for those seeking to learn more about Harbor Oaks history or simply the public at large who might pick it up, never imagining there might be a connection to their hometown from this corner of the Sunshine State where they, for whatever reason, ended up living or vacationing. Whatever the future holds for Harbor Oaks, a few things are certain. Dean and Donald Alvord introduced the state of Florida to visionary land-planning techniques and the concept of deed restrictions. However, the real treasure of Harbor Oaks lies not in the homes but in the people who built, bought, and lived in them. These are the pioneers who have impacted the local history of Clearwater, Florida, and, in fact, the entire history of our country. So, the legacy of Harbor Oaks is in place, and that can never be diminished. Long live Harbor Oaks!

—Michael L. Sanders

One

DEAN ALVORD AND THE NEW YORK CONNECTION

According to Samuel Morgan Alvord's *A Genealogy of the Descendants of Alexander Alvord, An Early Settler of Windsor, Conn. and Northampton, Mass.*, Dean Albert Alvord was born on December 4, 1856, in Syracuse, New York, the son of James Dwight Alvord and Caroline Louise Edwards. After growing up in Syracuse and attending Syracuse University (he graduated in 1882 with a degree in education), Alvord worked as a teacher, book salesman, investment securities salesman, and secretary of the Rochester YMCA (where he help to plan and build a new $125,000 facility) before becoming a real estate agent and developer in Rochester in 1890.

Success with his first development, which consisted of 40 lots, was followed by a move to Brooklyn in the 1890s, where he created the iconic Prospect Park South. Cleverly dubbed by Alvord as the "rus in urbe" (country in the city), Prospect Park South—with its substantial homes (most exceeded 3,500 square feet), numerous deed restrictions, and trees planted to create the illusion that each house resided on its own city lot—has often been considered the forerunner of the modern suburb. Prospect Park South also introduced the pioneering concept of a tree-lined median placed in the middle of the street—a design that Alvord would later incorporate into Harbor Oaks as well. As a result, many residents of wealthy neighborhoods in Manhattan moved to the Prospect Park South suburbs to take advantage of the illusion of rural living with easy access to New York City and adjacent boroughs. Alvord simultaneously developed both the Belle Terre community on Long Island's North Shore and Roslyn Heights in the Roslyn area of Long Island. He was also a principle participant in the acquisition of land for what became the Garden City Estates, the Shinnecock Hills development, and Laurelton.

Alvord's successful use of philanthropic and beautification efforts to not only enhance the housing developments he created in New York but to attract potential residents to purchase properties became the cornerstone of his efforts to produce similar results in his Florida projects. However, according to the primary authoritative text on the Harbor Oaks development, 1987's *Harbor Oaks: A Historic and Architectural Survey and Presentation Plan*, Harbor Oaks (and Alvord's housing development efforts in Florida) came about primarily by accident.

This particularly high-quality photograph of Nellie, Dean, and a young Donald Alvord was probably taken on the east coast of Florida around 1900. Nellie Alvord was a descendant of the Barnum family from the well-known entertainment-and-circus enterprise. All Alvord children, including Donald, were given the Barnum middle name. (Courtesy of Lynn Flaster.)

This picture shows Dean Alvord and his son Donald around 1910 or 1911 in the Belle Terre community that they developed on New York's Long Island. Dean Albert Alvord was born on December 4, 1856, in Syracuse, New York, the son of James Dwight Alvord and Caroline Louise Edwards. Donald Alvord was born on February 27, 1892. He was Dean and Nellie Alvord's second child; their first son, Harry, was born on June 12, 1886, and died in infancy. (Courtesy of the Village of Belle Terre.)

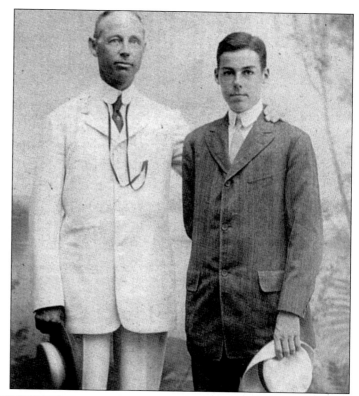

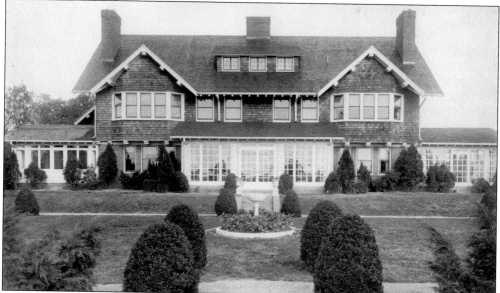

This fine example of an English Tudor–style home was named Nevalde and was built by Dean Alvord for himself in Belle Terre ("beautiful land"). It was used as a focal point of sophisticated advertising. Elegant brochures were produced advertising Belle Terre as a place where one could create a "perfect home in perfect surroundings." Alvord championed "refinement" and "good taste" and was careful to note that membership in Belle Terre depended on these qualities rather than solely upon wealth. (Courtesy of the Village of Belle Terre.)

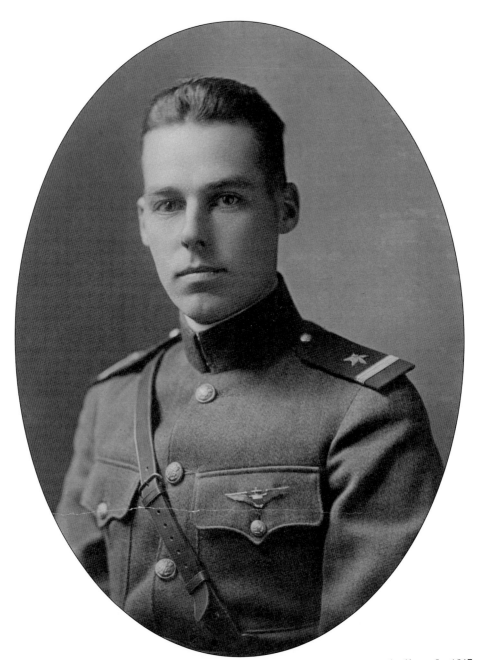

Donald Alvord is photographed here shortly after becoming a commissioned officer. In 1917, at the age of 25, Donald traveled to Washington, DC, to pursue a career in military aviation. He apparently sought out Franklin D. Roosevelt (then assistant secretary of the Navy) and asked him to personally authorize his enrollment in military flight school. With this accomplished, he reported to flight school in Buffalo, New York, and then was sent to Europe (probably first to London, then to France). Miraculously, he returned unscathed to Clearwater in 1919 and resumed the lead in developing Harbor Oaks. Equally as surprising, Pinellas County court documents support that Donald Alvord was in fact the legal owner of the Harbor Oaks development throughout his daring military service. (Courtesy of Lynn Flaster.)

Two

HABOR OAKS
INITIAL DEVELOPMENT

In 1910, Dean Alvord decided to establish a permanent winter residence in Florida (having been introduced to the Florida east coast by Henry Flagler, who had sought his advice on financing housing developments in the Miami area). In early 1913, Alvord decided to make his winter home in Clearwater. He identified a plot of land that had recently been purchased by Edwin. H. Coachman from the Fort Harrison Orange Grove Company (which was established by the heirs of Augustus B. Ewing and David B. Gould of St. Louis in 1904); Coachman had divested of the Grove Company's orange crop prior to offering the land for sale.

Apparently, Alvord wanted a small portion of the property to build his estate; however, Coachman would not sell the land in parcels. Alvord purchased the entire 55-acre property for $40,000, putting $10,000 down, and Coachman financed the balance over three years at six-percent interest—setting the stage for the project that became Harbor Oaks. The same day of this purchase in February 1913, Dean and wife, Nellie Barnum Alvord, proceeded to sell the entire property to young son Donald. There are various reasons speculated for this legal maneuver, but the most likely was the fact that Dean Alvord's last and most ambitious New York project, Belle Terre, was at the time descending into receivership. Dean, nevertheless, quickly proceeded to build a Colonial Revival–style stucco home in Harbor Oaks at 802 Druid Road to serve both his speculative and short-term residential needs.

Drawing from his experience establishing Belle Terre, Alvord and oldest son Donald set out in the 1910s to create an "exclusive" neighborhood with amenities not typically associated with Florida development. Thus, what became today's Harbor Oaks neighborhood originally featured graded and paved roads, curbs, gutters, concrete sidewalks, buried utilities, and decorative brick pillars placed strategically at various entrances to the project.

When Harbor Oaks opened initially in late 1913, the Alvord development's basic infrastructure was partially completed. Efforts were made to preserve the natural beauty of the coastal landscape by maintaining a small lake and marsh in addition to planting numerous swamp oaks and palm trees along the parkways (similar to what Alvord did in Brooklyn's Prospect Park South). Tragically, the small lake and marsh situated between the eastern ends of Jasmine Way and Magnolia Drive proved deadly when one of E.H. Coachman's sons drowned in the lake. Subsequent efforts to promote residential safety and protect the exclusivity of the Harbor Oaks neighborhood were the positive by-product of the tragedy and, achieved through the use of deed restrictions, were precursors to municipal zoning and land-use controls. Benefits of such well-supported neighborhood governance were described in the Harbor Oaks Association's bylaws, which said, "The charm of Harbor Oaks . . . lies in the uniformity of planting and the continued upkeep of the plants, palms, trees, and parks . . . a gardener employed early by the Association is necessary for this work."

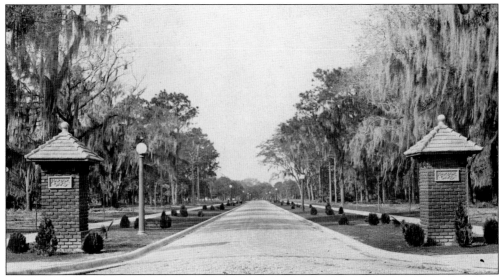

In this photograph of the entrance to Harbor Oaks at Druid Road, the wide angle of the shot gives viewers an understanding of the overall size of the community, owed to the fact that Dean Alvord was prompted to purchase all 55 acres of the land associated with the Fort Harrison Orange Grove Company from E.H. Coachman (who refused to divide the land into smaller parcels). (Courtesy of Michael L. Sanders.)

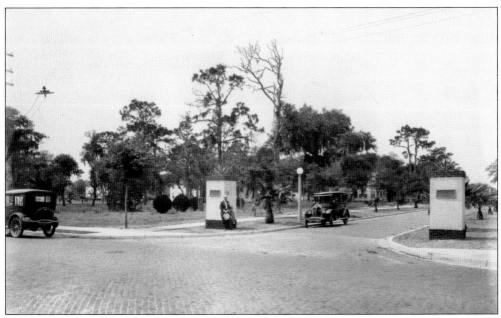

In this view, both the evidence of urban planning and the incorporation of community infrastructure are clearly visible. The entrance posts and gaslight globe–style lighting establish both visual boundaries and physical lines of demarcation for prospective homeowners and construction personnel. This photograph is most likely from around 1920, based on the fact that brick was used as the primary paving material for early Harbor Oaks streets. (Courtesy of the Tampa-Hillsborough County Public Library System—Burgert Bros. Collection.)

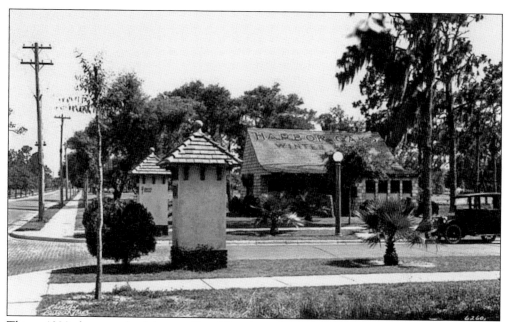

This c. 1920 photograph of the east Druid Road entrance to Harbor Oaks illustrates some of the marketing strategies the Alvords chose to attract wealthy individuals to purchase lots and homes. Note the prominent placement of the words "Harbor Oaks Winter Homes" on the roof of the original sales office. (Courtesy of the Tampa-Hillsborough County Public Library System—Burgert Bros. Collection.)

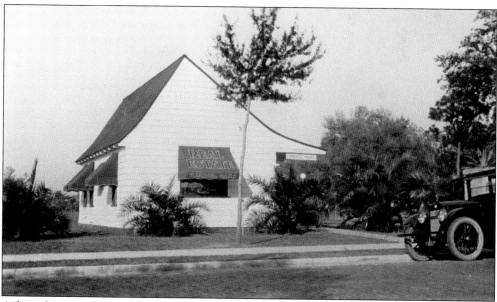

A front-facing view shows the Donald Alvord Harbor Oaks Real Estate office at 900 South Fort Harrison Avenue, positioned at the southwest corner of the Jasmine Way intersection. This structure, photographed around 1922 or 1923, was actually the second Alvord real estate office as a similar, slightly smaller office (shown at top) was originally situated one block north on the southwest corner of Druid Road and Fort Harrison Avenue. This newer building (above) was later purchased and used as the dental office of Doctor Hemerick. (Courtesy of Heritage Village.)

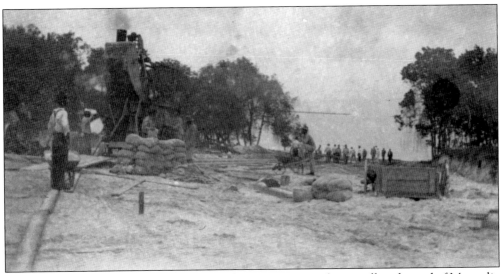

This photograph from around 1913 depicts the construction of a seawall at the end of Magnolia Street and the subsequent road paving that brought the end of the road to Clearwater Bay. Note the tools and construction methods for building the roadbed and the tower structure in the background, probably used to manufacture the asphalt-type material applied to Harbor Oaks roads. (Courtesy of Heritage Village.)

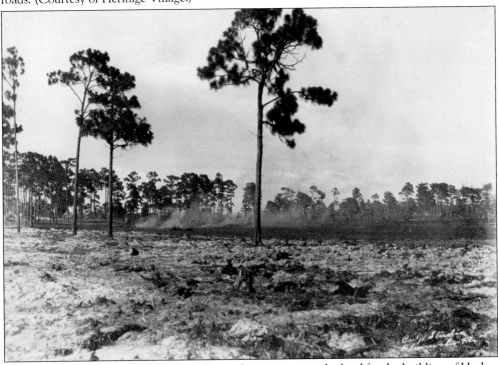

This early-1913 photograph shows work being done to prepare the land for the building of Harbor Oaks, which here looks more like a battleground than a development. Tall pines towering over low-lying vegetation indicate that this may have originally been forestland and not part of the Fort Harrison Orange Grove, which Dean Alvord purchased from E.W. Coachman back in 1911. (Courtesy of the Cooper family collection.)

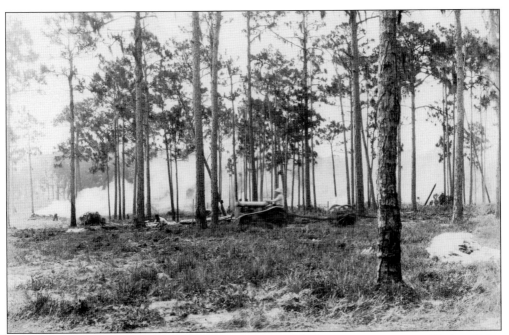

Here is another shot of land being cleared and prepared for home construction in Harbor Oaks. While the total number of acres (67) was relatively small by today's development standards, the configurations and possible combinations (including waterfront properties and estate-sized double lots) offered a large variety. (Courtesy of the Cooper family collection.)

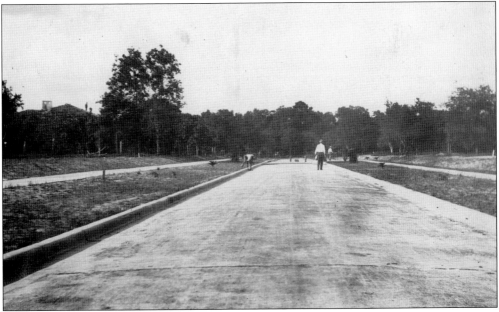

This photograph, which appears to have been taken between 1913 and 1915, shows the basic structure of roads, curbs, and sidewalks in Harbor Oaks. Surveyors (and possibly Dean Alvord himself) are pictured examining some of the paving and curbing work already completed. Harbor Oaks, located at latitude 38 degrees north, eventually contained more than 70 homes. (Courtesy of Heritage Village.)

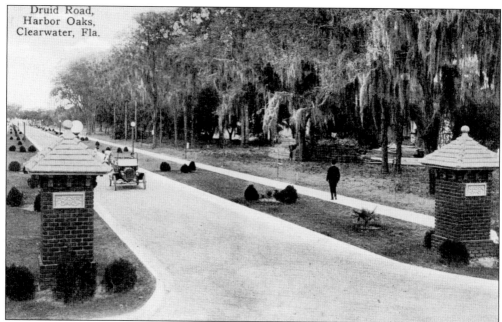

This page from the 1916 Harbor Oaks sales brochure features the main entrance to the community and gives prospective buyers an indication of the lush landscaping that envelops the common areas of the neighborhood (most likely funded by the homeowners' association dues that became part of the development's governance structure). The caption in the brochure reads, "Druid Avenue entrance. Provision has been made for the perpetual maintenance of parkways, which are broad and well kept." (Courtesy of Frank Hibbard.)

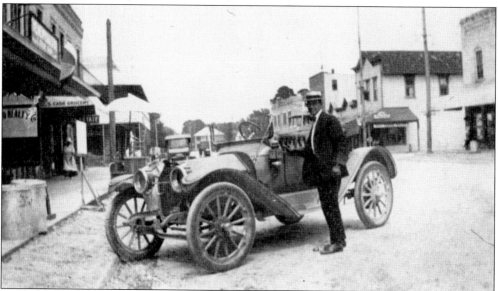

A 1911 look at Cleveland Street in downtown Clearwater (shortly after the 1910 fire that mandated wooden buildings be replaced with brick ones) includes this vintage automobile. Also pictured is Dr. John Bowen, founder of Clearwater's Morton Plant Hospital. When Harbor Oaks streets were laid out, the average width of a vehicle (such as the Ford Model T) was 66 inches. (Courtesy of Heritage Village.)

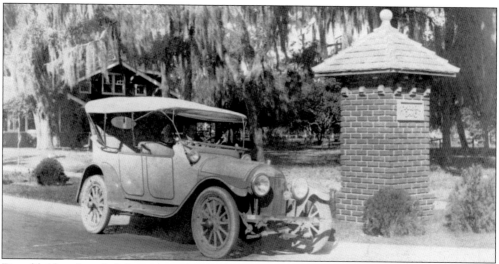

Donald Alvord mailed this postcard to his brother in June 1916. The image shows what appears to be the east entrance to Harbor Oaks off Druid Road with a 23-year-old Donald driving his new 1915 Chevrolet Series H touring car. The signature Alvord entrance-pillar design, with canopy roof encased in tile and a molded medallion affixed to the top, is clearly visible. Also in view is the Bungalow-style E.C. Price house, located at 430 Druid Road West, built c. 1914. It is a two-story bungalow with an interesting front porch design. (Courtesy of Michael L. Sanders.)

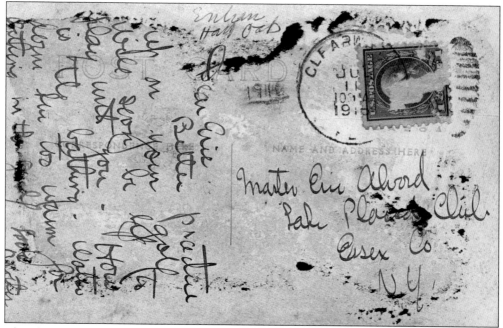

This photograph shows the back of the same postcard and Donald Alvord's handwritten message to younger brother Eric, age 13, who at the time was spending his summer at the restricted-membership Lake Placid Club. Donald reports, "Water down here too warm for bathing in the gulf. Love Brother." Within a year, Donald volunteered for US military pilot training and spent the latter half of 1917 and much of 1918 in the United States and Europe learning to fly, all the while being the legal owner of Harbor Oaks. (Photograph courtesy of Michael L. Sanders.)

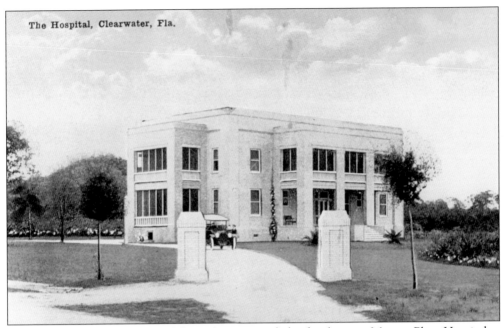

The Hospital, Clearwater, Fla.

This c. 1916 photograph is one of the earliest views of what has become Morton Plant Hospital—Clearwater's main hospital facility. It was built between 1914 and 1915 with funds provided by Morton Plant (via a $100,000 endowment and $20,000 raised by Clearwater's citizens) to service the needs of the community and seasonal residents who wintered at the nearby Hotel Belleview and Cottages. The hospital has become a major presence in the Tampa Bay area, with numerous satellite locations throughout Pinellas County. It is said that babies were initially delivered inside the facility's screened porch. (Courtesy of the Harold Wallace Estate.)

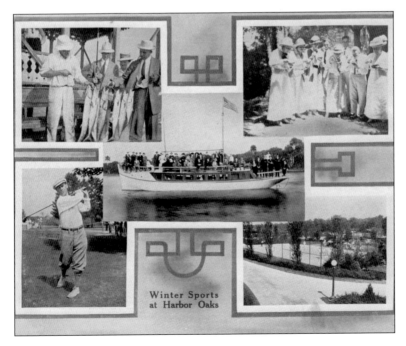

Winter Sports at Harbor Oaks

As part of the promotional campaign to attract potential residents, Dean Alvord chose to profile some of the more popular recreational sports that many of the area's wealthy winter residents pursued. (Courtesy of the Cooper family collection.)

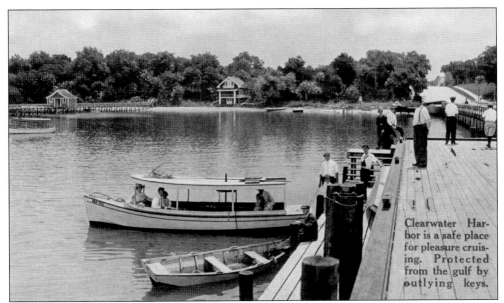

Clearwater Harbor is a safe place for pleasure cruising. Protected from the gulf by outlying keys.

Looking almost like a sparsely populated island, the area around the Clearwater Harbor (as viewed from the Cleveland Street pier) can be seen with boats and activity taking place at the docks. Of course, the present-day view of the same location is much different. This photograph from the 1916 Harbor Oaks sales brochure has a caption that reads, "Clearwater Harbor is a safe place for pleasure cruising. Protected from the Gulf [of Mexico] by outlying keys [for example, Clearwater Beach]." (Courtesy of the Harold Wallace Estate.)

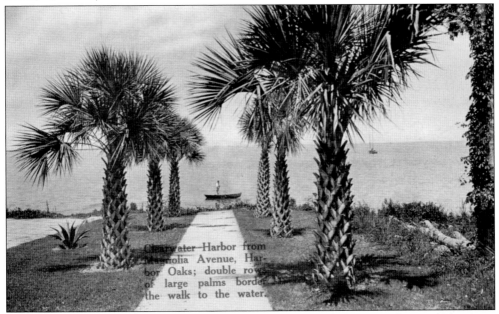

Clearwater Harbor from Magnolia Avenue, Harbor Oaks; double rows of large palms border the walk to the water.

This image, taken from the 1916 Harbor Oaks sales brochure, features a tranquil view of Clearwater Harbor from the end of Magnolia Avenue (later renamed Magnolia Drive). Mexican fan palms flank the sidewalk and are referenced in the caption found at the bottom of the photograph, which reads, "Clearwater Harbor from Magnolia Avenue, Harbor Oaks; double rows of palms border the walk to the water." (Courtesy of Frank Hibbard.)

23

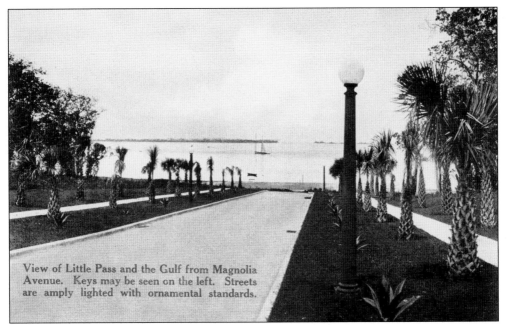

View of Little Pass and the Gulf from Magnolia Avenue. Keys may be seen on the left. Streets are amply lighted with ornamental standards.

This early photograph of the end of Magnolia Road from the Harbor Oaks sales brochure gives prospective buyers better understanding of the natural beauty of Clearwater's coastal terrain. The caption reads, "View of Little Pass and the Gulf [of Mexico] from Magnolia Avenue. Keys may be seen on the left. Streets are amply lighted with ornamental standards." Little Pass was the name given to what would be eventually known as Clearwater Pass. (Courtesy of the Harold Wallace Estate.)

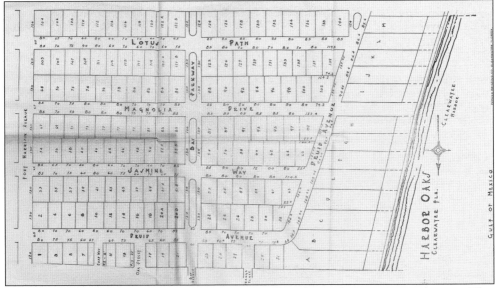

This detailed depiction of Harbor Oaks is the official Harbor Oaks Association plat map. This section from a c. 1914 Pinellas County plat map shows each property and its dimensions as outlined for both surveying and property tax–valuation purposes (the latter being a new concept at the time). Alvord's use of the double-lot development structure is also clearly evident in this graphic. (Courtesy of Gyneth Stanley.)

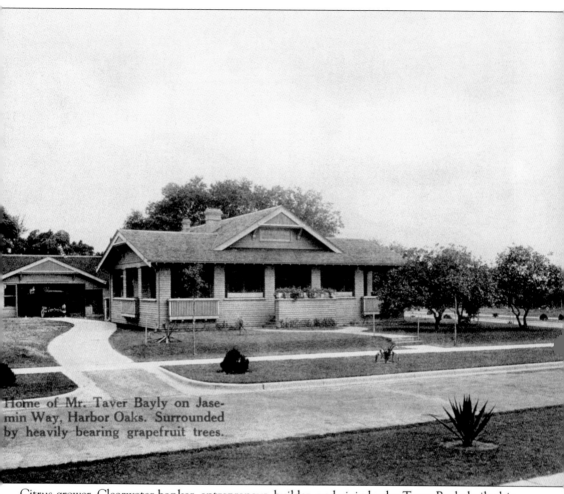

Home of Mr. Taver Bayly on Jasemin Way, Harbor Oaks. Surrounded by heavily bearing grapefruit trees.

Citrus grower, Clearwater banker, entrepreneur, builder, and civic leader Taver Bayly built this modest Bungalow-style home at 301 Jasmine in 1914 at the mere age of 24. Note the expanded eaves and Alvord-style fascia treatment, which added depth to the facade of the home's conservative footprint. (Courtesy of Frank Hibbard.)

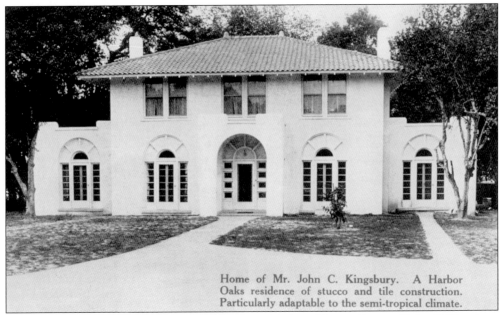

Home of Mr. John C. Kingsbury. A Harbor Oaks residence of stucco and tile construction. Particularly adaptable to the semi-tropical climate.

This 1916 promotional photograph shows the adapted Colonial Revival home of John C. Kingsbury and his wife, Natalia, located at 800 Druid Road West. Having previously resided on Osceola Street (according to the 1914 city directory), Kingsbury was a cashier at the People's Bank who, like Taver Bayly, rose through the ranks to become its vice president. (Courtesy of Frank Hibbard.)

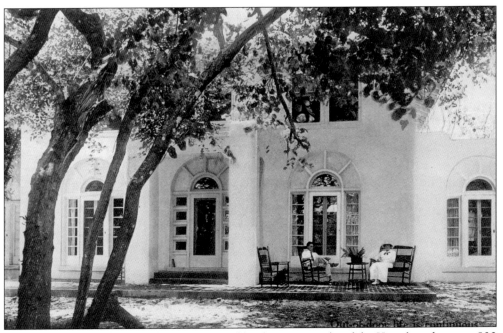

The ornate arches and natural canopy created by the swamp oaks of the Kingsbury home at 800 Magnolia are clearly visible here as the home's owners enjoy a morning coffee outdoors. The second-story windows, while not as ornate as the lower-level ones, are still quite impressive for their size (rare at the time). (Courtesy of Heritage Village.)

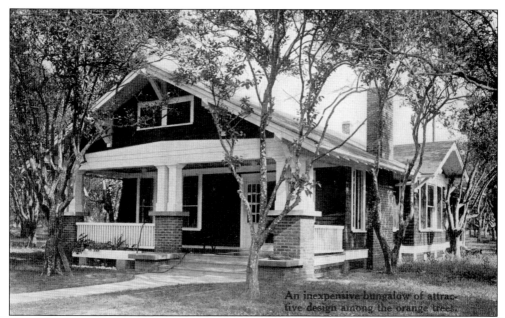

An inexpensive bungalow of attractive design among the orange trees.

Of course, not all Harbor Oaks homes were estate-sized. Modest, inexpensive designs—particularly those built in the California Bungalow style—were also popular. This photograph from the 1916 Harbor Oaks sales brochure has a caption that reads, "An inexpensive bungalow of attractive design among the orange trees," referencing the former Fort Harrison Orange Grove on which Harbor Oaks sits. (Courtesy of Frank Hibbard.)

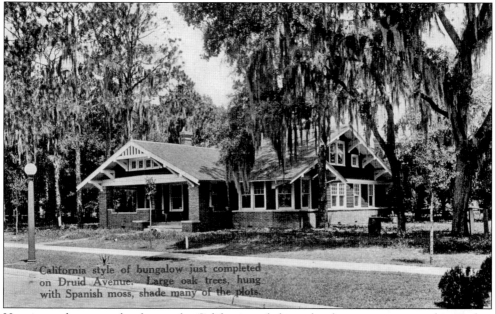

California style of bungalow just completed on Druid Avenue. Large oak trees, hung with Spanish moss, shade many of the plots.

Here is another example of a popular California-style bungalow home as constructed in Harbor Oaks between 1914 and 1915 at 430 Druid Road West. This photograph appeared in the Harbor Oaks sales brochure, and the caption reads, "California style of bungalow just completed on Druid Avenue. Large oak trees hung with Spanish moss shade many of the plots." (Courtesy of the Harold Wallace Estate.)

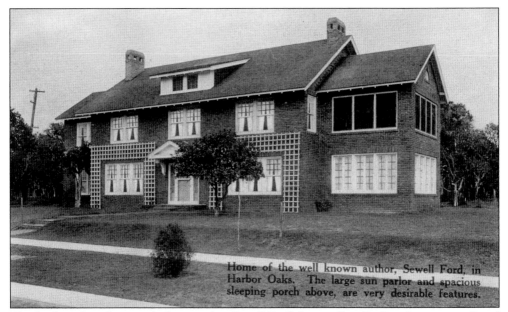

Home of the well known author, Sewell Ford, in Harbor Oaks. The large sun parlor and spacious sleeping porch above, are very desirable features.

This high-quality photograph shows author Sewell Ford's house, Casa De San Antonio, on Druid Road around 1915. Ford's anecdotal presentations of early-20th-century life have just recently been uncovered in modern literary-criticism circles. Other Ford novels included adventure stories centered around horses and depicting areas in the western United States. (Courtesy of Frank Hibbard.)

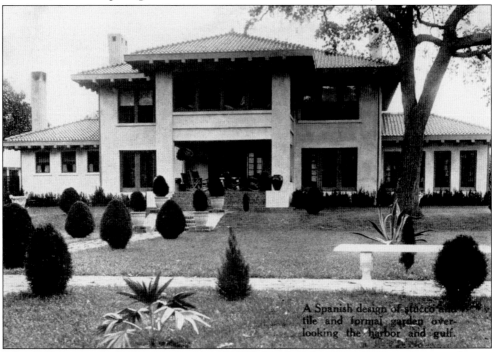

A Spanish design of stucco and tile and formal garden overlooking the harbor and gulf.

Alvord chose to include this image in the 1916 Harbor Oaks brochure to give prospective buyers a sense of the Florida style of architecture, as shown in this Spanish Mediterranean home design (the first Dean Alvord speculation home). The caption reads, "A Spanish design of stucco and tile and formal garden overlooking the harbor and gulf." (Courtesy of the Harold Wallace Estate.)

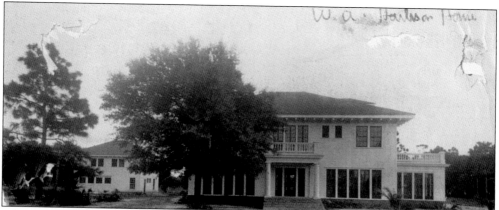

The William A. Harbison house at 403 Magnolia is seen here shortly after its completion in 1918. The detached servants' cottage is seen to the left. Harbison, from Pittsburgh and then White Plains, New York, inherited from his father a Pennsylvania-based firebrick- and cement-products refractory empire. (Courtesy of the Harold Wallace Estate.)

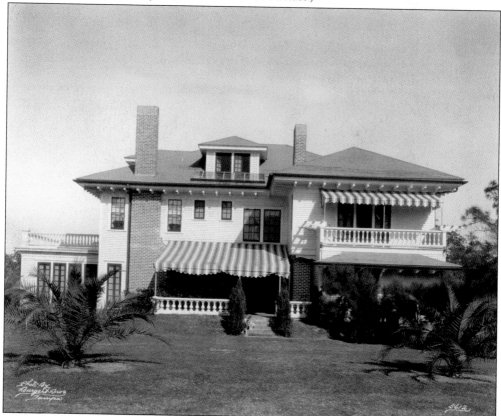

While many homes in Harbor Oaks had impressive front facades, several appeared just as impressive or even more so from the rear. When one views the Harbison house in this c. 1920 photograph, the eye is drawn immediately to the wide awnings and balustrades used in the outdoor spaces. Also notable are the heights and placements of the windows, particularly those flanking the chimney and those of the sunroom in the image's lower left quadrant. (Courtesy of the Tampa-Hillsborough County Public Library System—Burgert Bros. Collection.)

COMMITTEES

Committee on
Finance
(1. E. C. Price (Chairman)
(2. Chas. L. Spence
(3. Robert S. Brown

Committee on Police
and Fire Protection
(1. Taver Bayly
(2. Frank J. Booth,
 (Chairman)
(3. James S. Gill

Committee on Street
and Parkways
(1. E. C. Price (Chairman)
(2. Donald Alvord
(3. J. B. McChesney
(4. Taver Bayly
(5. John T. Bowen

Committee on Taxa-
tion and Assessment
(1. Dean Alvord,
 (Chairman)
(2. J. C. Kingsbury
(3. E. C. Price

Committee on Public
Utilities
(1. J. B. McChesney,
 (Chairman)
(2. Paul F. Randolph
(3. H. D. Yerxa

Committee on Law
and Legislation
(1. M. A. McMullen
(2. Norman Beecher,
 (Chairman)
(3. Walter Bass

HARBOR OAKS ASSOCIATION

HARBOR OAKS

Clearwater, Fla.

THE BY-LAWS

ARTICLE I.

NAME

This Association shall be called HARBOR OAKS AS-SOCIATION.

ARTICLE II.

OBJECTS

The objects of this Association are to promote the mutual interests of the members as owners of property in Harbor Oaks, to assist and advise with the officers of the City of Clearwater in all proper efforts to advance public welfare, to maintain the present high grade of public and private improvements, to add to the attractions and advantages of HARBOR OAKS as a place of residence, to observe and support such needful regulations and restrictions as will foster public spirit in the members and preclude the advent of undesirable tenants or proprietors and to act as the representative and agent of all the property owners in the collection and disbursement of the moneys raised by yearly assessments upon property owners under the terms of their contracts respecting the care, cleaning and maintenance of the streets, roads and parkways in Harbor Oaks.

This photograph shows a 1927 listing of the members of the Harbor Oaks Homeowners' Association. Many of the notable residents, such as Robert S. Brown, E.C. Price, and others, joined Dean Alvord in serving on various committees. The right side of the page outlines the objectives of the association. (Courtesy of Gyneth Stanley.)

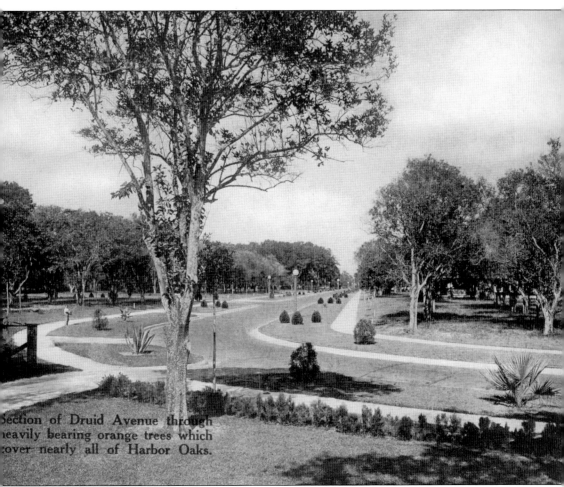

Section of Druid Avenue through heavily bearing orange trees which cover nearly all of Harbor Oaks.

With the Harbor Oaks community not having reached full development until sometime in the early 1940s (nearly 30 years after initial development began) the existence of empty lots alongside established homes and landscaping was not uncommon. Both the end of the Florida Land Boom of the 1920s and the onset of the Great Depression were underlying reasons for the time lapse between the development's initial launch and its completion. (Courtesy of the Tampa-Hillsborough County Public Library System—Burgert Bros. Collection.)

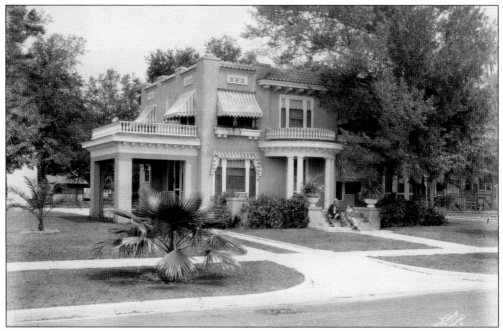

This iconic Harbor Oaks residence was built for Clearwater mayor Frank J. Booth in 1923. Booth, a commercial realtor based in Clearwater's downtown area, served as mayor from 1920 to 1926. Mayor Booth is seen in this 1924 photograph sitting on the front stoop. Clearwater attorney Chester B. McMullen Jr. and his wife, Ruth Dean McMullen, purchased the home from Booth in 1949. (Courtesy of the Ruggie family collection).

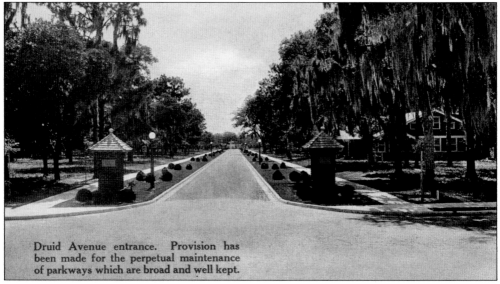

Druid Avenue entrance. Provision has been made for the perpetual maintenance of parkways which are broad and well kept.

In this picture of one of the Harbor Oaks entrances, Alvord's attempts to incorporate local terrain and horticultural elements as landscape accents evokes an image that can only be classified as a "refined Florida scene." With the neighborhood's fully developed infrastructure (including brick pavers, curbing, and street lighting) in clear view, the overall effect that Alvord sought—that of a complete planned community for discriminating buyers—is well represented here. (Courtesy of the Tampa-Hillsborough County Public Library System—Burgert Bros. Collection.)

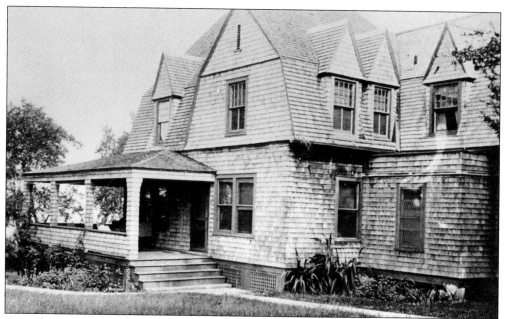

According to noted Clearwater historian Michael L. Sanders, this Shingle-style Victorian home known as the Kidder-Pearce house (with its unusual gambrel roof) was built in 1896 on Lime Avenue. Both Kidder and Pearce were mayors of Clearwater, in 1901 and 1910 respectively. The building's design was rare for the era and for the west coast of Florida. Built directly opposite of Clearwater Pass, it would catch the prevailing winds off the water. As a result, the temperature of the side porch was several degrees warmer than that of the front porch. The home was torn down in the 1970s. (Courtesy of Michael L. Sanders.)

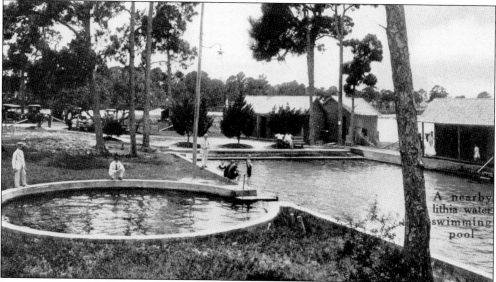

Spas and mineral baths were—and still are—a welcome respite for weary Northerners wishing to escape the harsh climates during the winter months. This picture of a Lithia pool from the 1916 Harbor Oaks brochure shows one of those locations. Some identify this photograph as being taken several hours north of Clearwater at Wall Springs in Ozona, Florida, where a mineral pool of the Florida land boom–era was located. (Courtesy of the Harold Wallace Estate.)

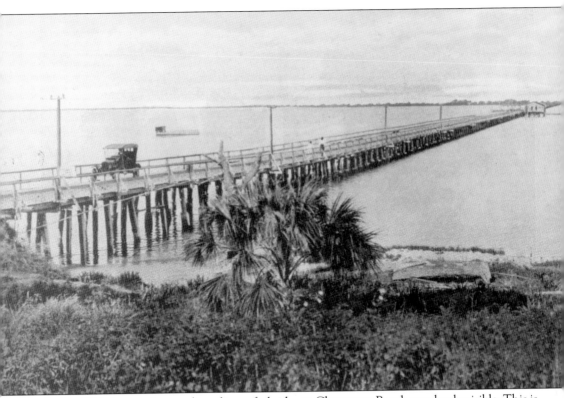

In this 1916 picture, the wooden pilings of a bridge to Clearwater Beach are clearly visible. This is believed to be the western extension of a small road off Fort Harrison Avenue named Seminole. James A. Miller is seen driving a 1913 Ford Model T across the east side of the bridge. (Courtesy of Heritage Village.)

As viewed from the side, this picture of a bay window with a spindled balustrade crown can be seen with mature palms and other vegetation in the background. Since Alvord used many traditional Northern architectural styles in the development, the appearance of the bay window as design element in many Harbor Oaks construction projects is not a complete surprise. Not only did these design elements have aesthetic beauty, they were also quite functional. (Courtesy of the Cooper family collection.)

Cottage-style architecture became popular in the early 1900s in Florida. Its appearance and execution in Harbor Oaks is no exception, particularly on some of the smaller land plots scattered throughout the neighborhood. This fine example of the cottage-style makes extensive use of canopy awnings—over the front flanking windows, above the main entry doorway, and on the left to cover a portion of the screened porch. (Courtesy of the Cooper family collection.)

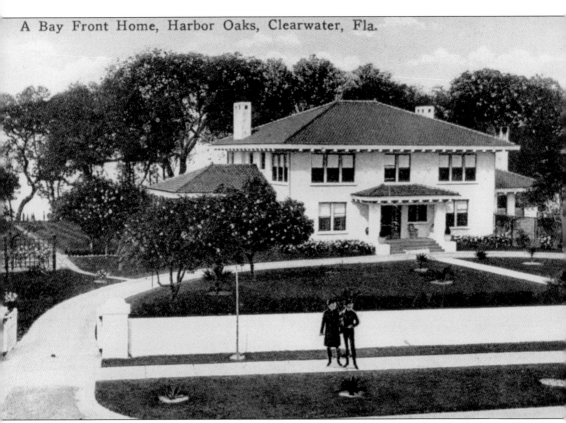

This home, originally built by Dean Alvord in 1914, was purchased by a friend of Alvord's from Rochester, New York, Kodak executive Edmund Lyon, who named it Century Oaks. Robert S. Brown, developer of one of the versions of the japan black paint used on millions of Ford Model Ts, bought the home from Lyon for $90,000 in 1922 and invested an additional $990,000 to expand the estate. (Courtesy of the Harold Wallace Estate.)

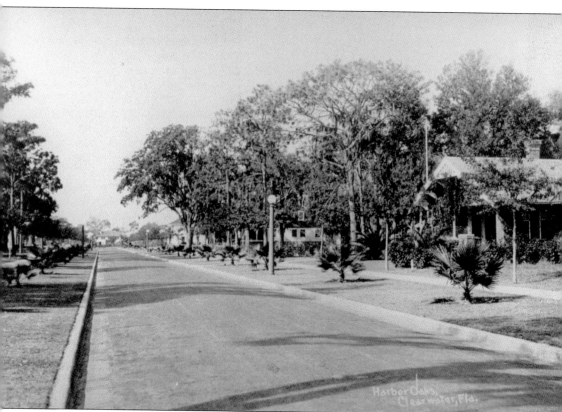

This snapshot of Harbor Oaks, taken around 1920, shows some of the early homes in the development as well as immature plantings. The view is of Druid Road looking west with the Price bungalow on the right. (Courtesy of Michael L. Sanders.)

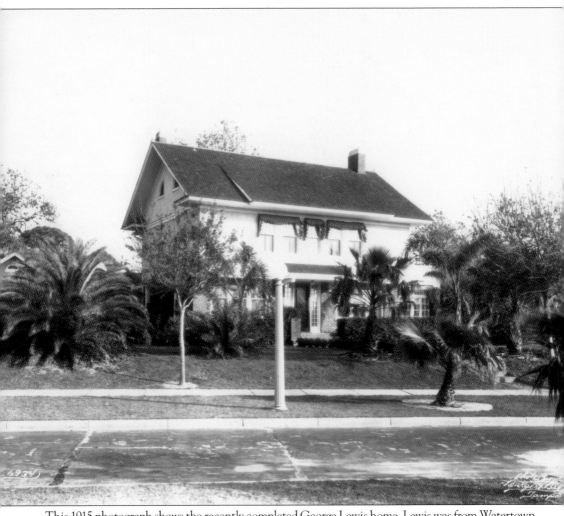

This 1915 photograph shows the recently completed George Lewis home. Lewis was from Watertown, Wisconsin. Records show that the home originally had a 909 Druid Road South address and fronting. The address was changed to 304 Magnolia in 1988 "to allow" for the building of a high security wall on the Druid Road property line. This structure has a traditional facade and is still meticulously maintained. Note the size of the few plantings in the tree lawn areas, evidence of the photograph's early provenance. (Courtesy of Heritage Village).

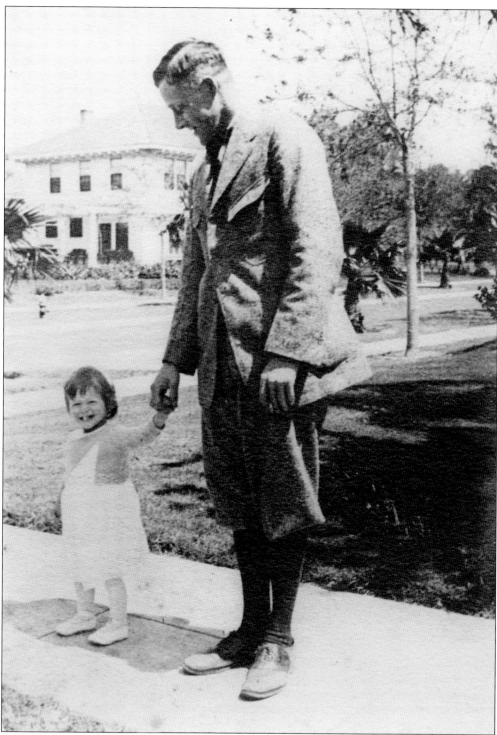

In this c. 1922 photograph, a young Ellie Fritz walks with her grandfather around the Harbor Oaks neighborhood. In the background, the second home of Dean Alvord at 318 Druid Road West is clearly visible, indicating this photograph was taken on Druid looking east. (Courtesy of Sue Williams.)

Panoramic view showing newly completed homes on Druid Avenue, Harbor Oaks.

This is likely the only photograph in existence of the "mobile" Edward Wright family house (on the left) that was moved by a team of horses over logs in 1914 from near Turner and South Fort Harrison Streets to its current site at 1001 Druid Road West. A young neighbor named Harold Wallace later confirmed to his son Bob in a 1975 audio recording that the Wright family lived in the home throughout the weeks-long moving process. It now appears that this home has since been completely rebuilt following the move as the current structure is massive and includes a stucco facade and three stories. (Courtesy of Frank Hibbard.)

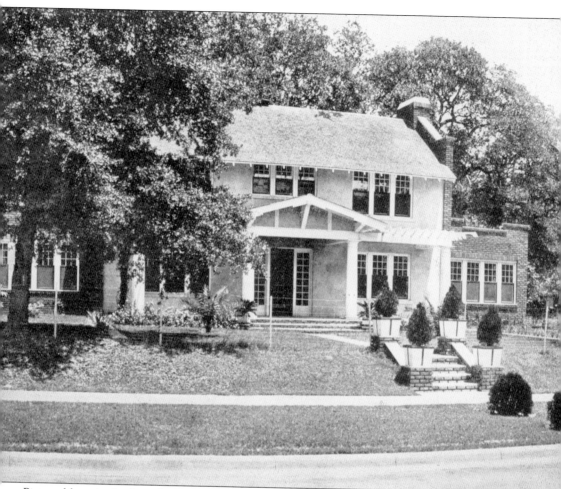

Pictured here is the Lyon house at 1005 Druid, which was built in 1915 by John B. Lyon from Chicago, who was involved in the lumber business. The original address was later changed to 302 Lotus Path. This home's guesthouse was adjacent to the original Wright family house and can be seen to the right in the photograph on page 40. (Courtesy of Frank Hibbard.)

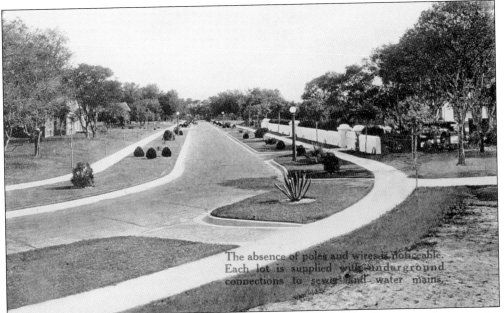

The absence of poles and wires is noticeable. Each lot is supplied with underground connections to sewer and water mains.

This photograph is significant not for its view of existing homes, landscapes, and community infrastructure (as seen between around 1925 and 1927) but rather for its reference to underground utilities access. Even the Harbor Oaks brochure includes a caption reading, "The absence of poles and wires is noticeable. Each lot is supplied with an underground connection to sewer and water mains." (Courtesy of Heritage Village.)

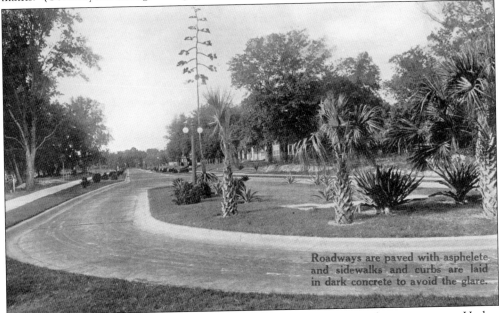

Roadways are paved with asphelete and sidewalks and curbs are laid in dark concrete to avoid the glare.

This was a small landscaped island in the middle of Druid Road at the southern entrance to Harbor Oaks, just south of Lotus Path. The island was later removed to make way for ambulance traffic approaching the nearby Morton Plant Hospital. Note the use of Mexican fan palms and other native landscaping as well as the configuration of the island—another example of Alvord's use of boulevard-style community infrastructure in his developments. (Courtesy of Frank Hibbard.)

This c. 1920 snapshot of Harbor Oaks shows some of the development's early homes and landscaping. One of those houses viewable in the distance to the right is the Dutch Colonial home owned by Richard Randolph, located at 411 Druid Road West. (Courtesy of Michael L. Sanders.)

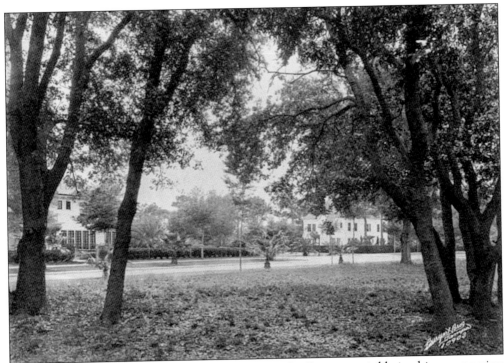

Some of Harbor Oaks' estate-sized homes on Magnolia Drive are visible in this canopy view from 1924. Manicured landscaping, as exemplified by the hedgerows flanking the two homes featured in the center of the image, reinforces the horizontal perspective that Alvord sought to emphasize in his larger designs. (Courtesy of the Tampa-Hillsborough County Public Library System—Burgert Bros. Collection.)

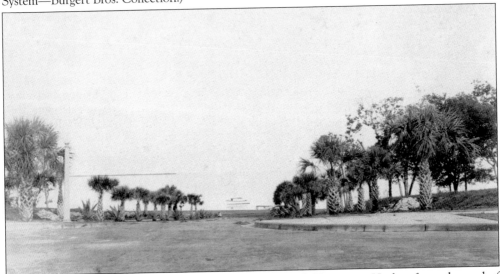

This photograph features an excellent, tranquil view of Clearwater Harbor from the end of Magnolia Avenue (later renamed Magnolia Drive). A child can be seen in the distance, playing near the water. Tropical landscaping is a focal point in the area, a fact reinforced in the Harbor Oaks brochure by a caption which reads, "Clearwater Harbor from Magnolia Avenue, Harbor Oaks; double rows of palms border the walk to the water." (Courtesy of Heritage Village.)

Three

HARBOR OAKS ARCHITECTURE AND NOTABLE DETAILS

Since both Dean and Donald Alvord selected house plans for use in Harbor Oaks that were primarily based on successful, well-known architectural styles of the late Victorian period, their ability to eventually sell these homes to wealthy buyers from America's East and Midwest locales proved to be successful as well. Not only did the architectural styles selected reflect current tastes, they also reflected unique aspects of adaptation with respect to Florida's sunny, semitropical climate.

For example, it appears that wide eaves, supported by heavy modillions, were incorporated into a majority of the designs not only to direct the sun's powerful rays away from the primary structure but also as a signature Alvord design feature of Harbor Oaks. Primarily used in the Prairie School of architecture, the wide eaves and modillion supports were indicative of the attempts by both Alvords to brand Harbor Oaks as a "labor of love, rather than a real estate speculation," according to an advertisement that appeared in the December 14, 1914 edition of the *St. Petersburg Daily Times*. In the same advertisement, Harbor Oaks is labeled "the Pearl of the Pinellas Peninsula."

Another Alvord adaptation of traditional architectural design to accommodate local climate and lifestyle was the use of the covered screened porch. Integrated into the basic footprints of most of the traditional architectural styles used, the screened porch element was achieved by removing the framing, sidewalls, and windows of a normal room in a home, replacing them with screens, and reinforcing infrastructure. These improvements allowed homeowners to enjoy the tropical breezes blowing off nearby Clearwater Bay without being subjected to Florida's insect population or its occasional humidity-induced rains. Architectural styles featured in Harbor Oaks included Mediterranean Revival, Prairie School, Colonial Revival (including Dutch and French Eclectic derivatives), Classical School, Bungalow (California-style and variations), Mission style (California), and Tudor Revival. Of these, the Mediterranean Revival style was incorporated into several of the notable homes in Harbor Oaks.

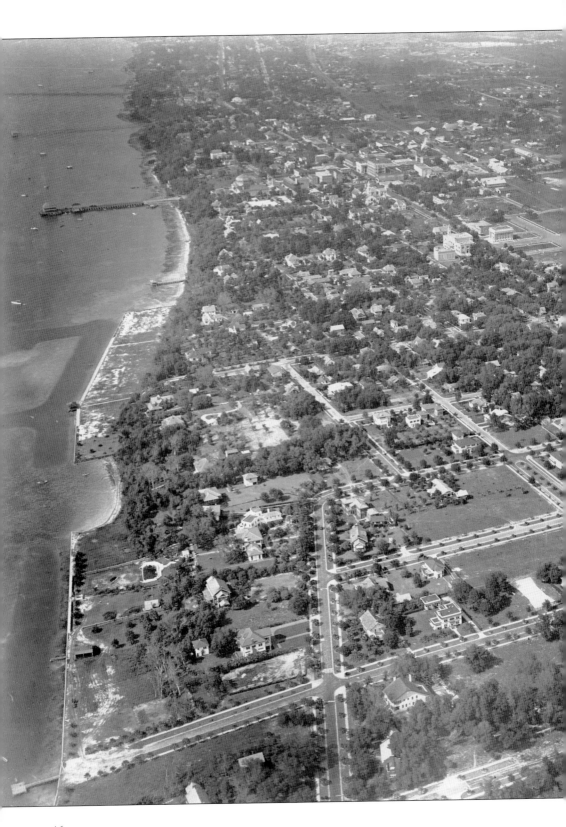

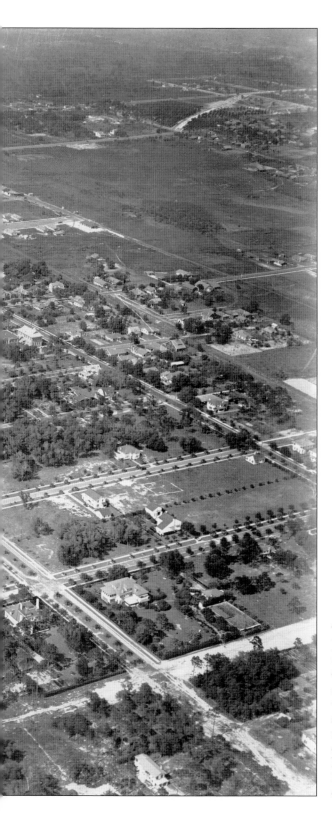

This interesting aerial view of Harbor Oaks looking north was taken between 1923 and 1924. One can clearly see that the area is still under development, with wide expanses of green space still visible even from this vantage point. The impact of Alvord's efforts to achieve harmony in the neighborhood layout is also apparent. (Courtesy of Heritage Village.)

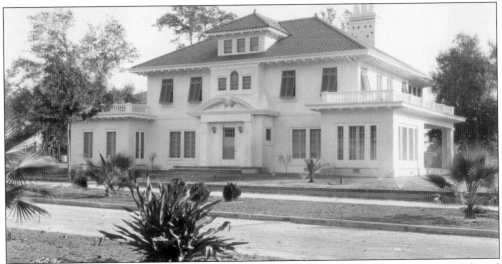

This impressive shot, dated 1920, shows the recently built Edmund C. Price house—a Colonial Revival derivative. Aptly labeled as an "Eclectic Revival" design, the structure demonstrates the wide range of home-design elements incorporated into the signature Alvord style that ultimately unified the community from an aesthetic perspective. This home at 301 Lotus Path features Alvord's signature application of wide soffits as well as the liberal use of Spanish Mediterranean design elements (the barrel-tile roof). (Courtesy of the Tampa-Hillsborough County Public Library System—Burgert Bros. Collection.)

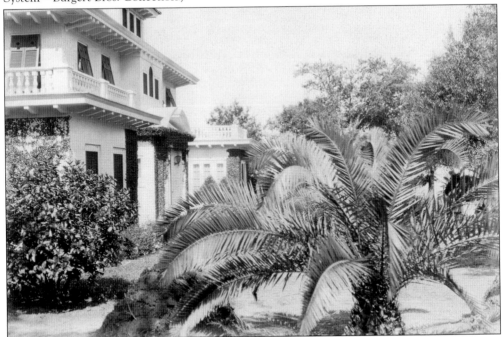

This is a 1924 photograph of the same home, which was built in 1920 by Chicago executive Edmund C. Price and sits on a double lot under a canopy of large oak trees on the corner of Druid South and Lotus Path. Situated at the southern entrance to Harbor Oaks, it is more than 5,800 square feet and includes six bedrooms, five baths, and two carriage apartments. (Courtesy of the Tampa-Hillsborough County Public Library System—Burgert Bros. Collection.)

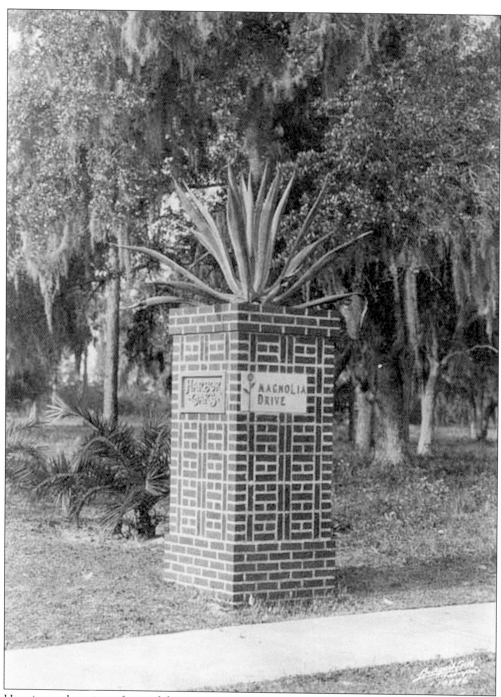

Here is another view of one of the posts gracing the entrance to Magnolia Drive. Not only does the brickwork incorporate a "castle" design pattern, the concrete Magnolia Drive sign embedded in the brick even features a flower to coincide with the street name's "flower-based origins." (Courtesy of the Tampa-Hillsborough County Public Library System—Burgert Bros. Collection.)

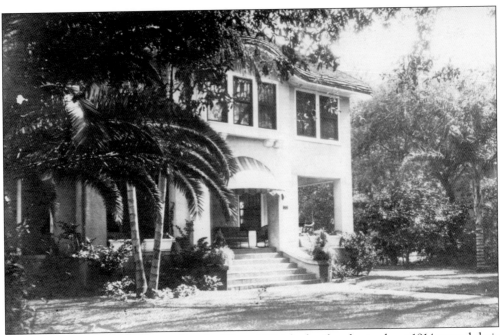

This property was originally owned by the Edward Wright family, who in about 1914 moved their bungalow from the Turner Street and South Fort Harrison Avenue area to this lot at 1001 Druid South. The Wrights sold their home to James S. Gill, president of the Jewell Woolen Mill in Ludlow, Vermont, in the early 1920s. Gill drastically enlarged and essentially rebuilt the home. The Mediterranean Revival structure features a stucco exterior with contrasting trim and accents and a particularly distinctive curving roofline. In this photograph, Florida flora is abundant, with king sago and other native palm species visible in addition to more traditional plants and shrubs. (Courtesy of the Cooper family collection.)

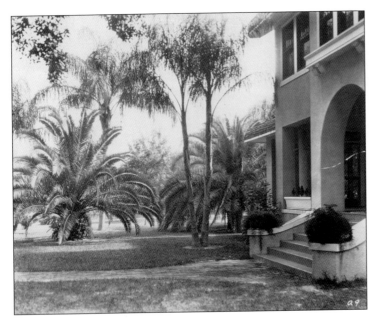

Here is another view of the Gill home that was originally owned by the Edward Wright family. The move of the Wright home took weeks, and the family continued to live in what was then a simple bungalow throughout its nearly one-mile transport. Harold Wallace as a teen witnessed the move and confirmed that Carrie Wright received milk deliveries at home during the move. (Courtesy of Michael L. Sanders.)

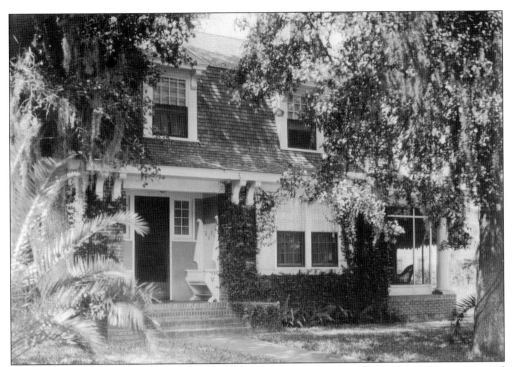

This view shows the home of successful Pinellas landowner Richard Randolph, who was a noted orange grower and local land developer. Pinellas realtor and Carlouel Yacht Club cofounder Paul Randolph (Richard's son) grew up here. Built in 1918, this excellent example of a Dutch Colonial is one of the few in existence on Florida's west coast. It features a unique front entry seat as well as a side porch with integrated Gothic columns. (Courtesy of Michael L. Sanders.)

Paul Randolph's son Dick (Richard's grandson) is seen atop the horse. The Randolphs were involved in real estate sales, land development, and horse breeding and also grew citrus on land in western Largo, south of Harbor Oaks, called Randolph Farms. (Courtesy of Heritage Village.)

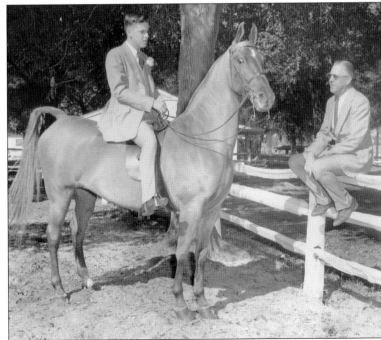

Originally owned by George and Eleanor Swift, this Bungalow-style home was built in 1915 on Druid Road West. Identified as a "Type III" configuration, this home features an adjacent sunroom, wraparound porch, and faux upper level with wide soffit and fascia. This postcard view presents a stylized perspective of the property, with Eleanor Swift on the front stoop. The Type III design proved to be quite popular in other areas of Harbor Oaks as well. (Courtesy of Michael L. Sanders.)

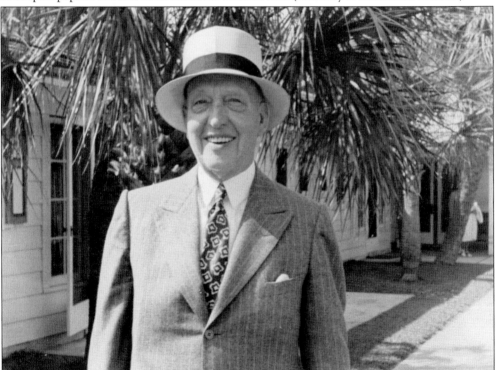

This is a photograph of George Swift, one of the charter members of the Carlouel Yacht Club. Founded in 1934 by Theron R. Palmer and Garret A. Hobart, Carlouel's cabanas and main clubhouse (seen behind Swift) were later improved (along with the development of a nearby housing community) by Harbor Oaks resident and realtor Paul Randolph. The inaugural roster included 100 members, and Carlouel operated seasonally until 1954; thereafter, it stayed open year round. (Courtesy of Michael L. Sanders.)

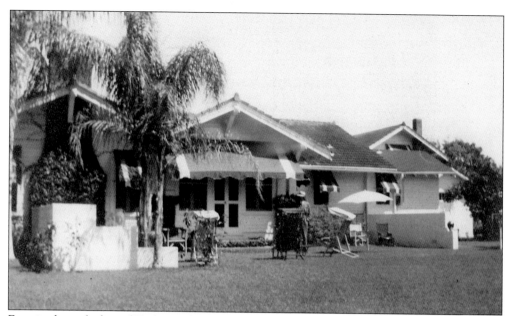

Even in the early days of Harbor Oaks' development, homeowners with a desire to take advantage of the expansive waterfront views had ample opportunity to showcase their horticultural abilities and create an oasis where plant life could mingle with aquatic life, as illustrated in this view of various plants and backyard structures. (Courtesy of the Tampa-Hillsborough County Public Library System—Burgert Bros. Collection.)

Here is a backyard view of the Druid Road home owned by George and Eleanor Swift. As previously mentioned, this Bungalow-style home was built in 1915 and is described as a "Type III" configuration. (Courtesy of Michael L. Sanders.)

As was later the case with many Florida housing developments created on vacated orange groves, vestiges of the land's former purpose were often evident. This view shows a small portion of the former Fort Harrison Orange Grove, and a few remaining buildings from the property are visible in the distance. (Courtesy of the Tampa-Hillsborough County Public Library System—Burgert Bros. Collection.)

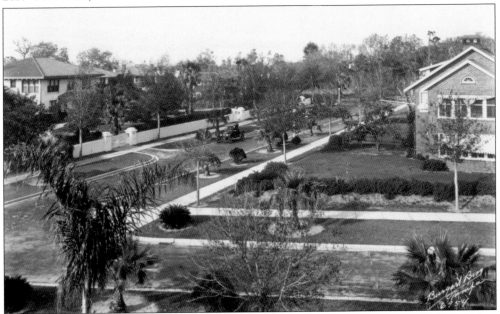

This image offers an interesting aerial view of Harbor Oaks' Druid Road looking north, complete with a full view of the tree lawn. To the left is the boundary of the Brown (Century Oaks) property, which includes what appears to be a concrete-and-stucco fence with integral pillars. To the right is Casa De San Antonio, the estate of author Sewell Ford. (Courtesy of the Tampa-Hillsborough County Public Library System—Burgert Bros. Collection.)

This mission-style home was built in 1922 on Druid Road West and was initially owned by attorney Melvin A. McMullen. McMullen eventually rose to become a circuit court judge. The home's unique design featured a central staircase with an elevated landing at the base to separate the living room and kitchen. The structure had a smooth, stucco facade; a flat, mission-style roof, and Mediterranean-styled wrought-iron balconies. The roof is composed of original green-glazed, S-shaped Ludowici-brand tile and at one point was painted red. The current owners, the Wrights, spent days stripping off that red paint. (Courtesy of Frank Hibbard.)

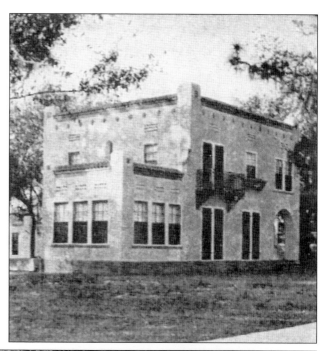

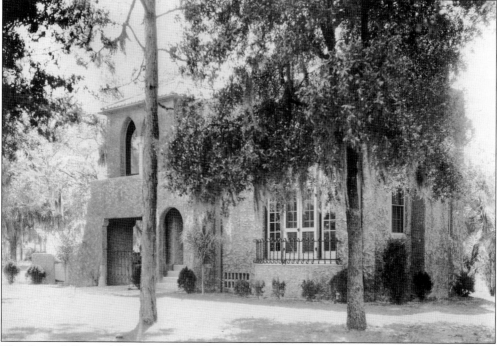

This Spanish Revival derivative, named Los Robles ("the Oaks"), was built in 1925 by Robert S. Brown for his son Raymond and features the traditional stucco facade but retains its origins in the use of arched windows above the carport. The arched entryway and faux balcony (with floor-to-ceiling French doors and dormer-style windows) also are unique design features. The home includes a fireplace (visible to the right) and gives a feeling of Mediterranean-style elegance in its use of native plants and trees. (Courtesy of the Cooper family collection.)

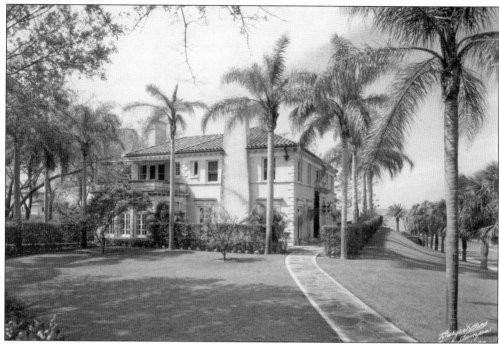

These photographs show the waterfront Plunkett/Alvord house at 205 Magnolia Drive from several vantage points. Originally planned as the residence of Herbert Harrison (founder of the Harrison Radiator Corporation) and his wife, Florence, it became a speculation home upon Herbert's untimely death in 1927. It was finally completed and sold to the Plunkett family in 1932. Donald Alvord bought the home from Plunkett in the 1940s. Note the covered portico and use of arched windows and doors. Block corner inlays (which appear to be marble) are also featured. (Both, courtesy of the Tampa-Hillsborough County Public Library System—Burgert Bros. Collection.)

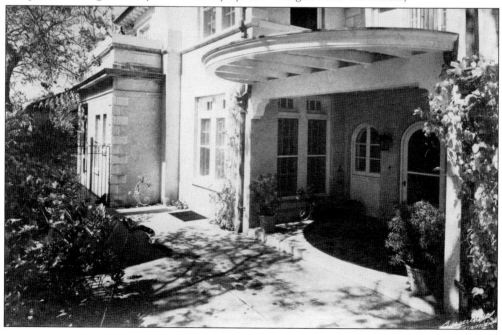

This dramatic image of the foyer entry to the Plunkett/Alvord estate highlights the cascading wraparound staircase and the cathedral doorway to the rear of the area. A hardwood railing and walnut landings give the staircase a classic feel. Alvord's penchant for Japanese flowers and Asian-inspired accessories is also evident. (Courtesy of Michael L. Sanders.)

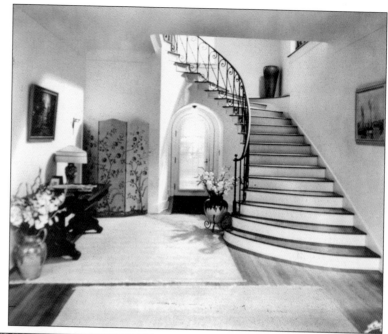

Unlike many Florida developments that failed to accommodate preexisting native flora, Harbor Oaks developers Dean and Donald Alvord sought to retain as much of the native greenery as possible. In this 1925 photograph, an existing home displays some of Florida's finest tropical greenery, including variegated palm varieties and ivy growing on the side of the dwelling itself. (Courtesy of the Cooper family collection.)

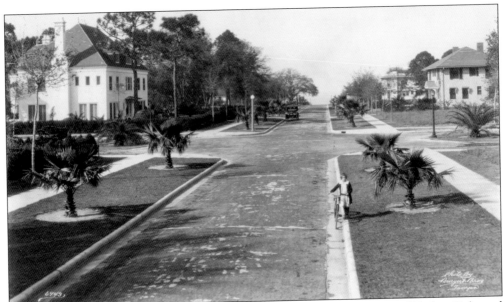

This 1921 westward view of Magnolia Drive shows both the general layout of Harbor Oaks and the individual lot sizes. To the right, a double-lot configuration is visible, and the undeveloped lots and Clearwater Harbor can be seen to the left and along the horizon. General home size is also indicative of the marketing strategy Alvord used for the community, which he touted as the "Riviera of the Sunny South." (Courtesy of the Tampa-Hillsborough County Public Library System—Burgert Bros. Collection.)

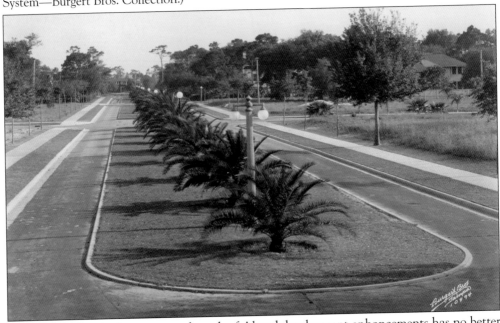

The boulevard style that was a trademark of Alvord development enhancements has no better representation than the example featured here. These two-way roads with wide medians and extensive landscaping were often flanked with period lighting in Alvord communities. A definite Florida feeling is evoked here in the exclusive use of queen palms in the median space. (Courtesy of the Tampa-Hillsborough County Public Library System—Burgert Bros. Collection.)

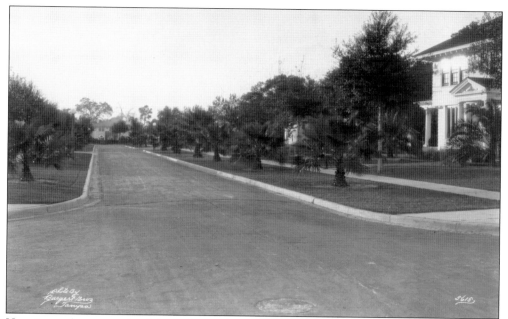

Here is another example of the wide tree lawns and narrow streets of Harbor Oaks as vehicle production was still in its infancy. Most street dimensions were still based on horse-drawn–carriage dimensions. (Courtesy of the Tampa-Hillsborough County Public Library System—Burgert Bros. Collection.)

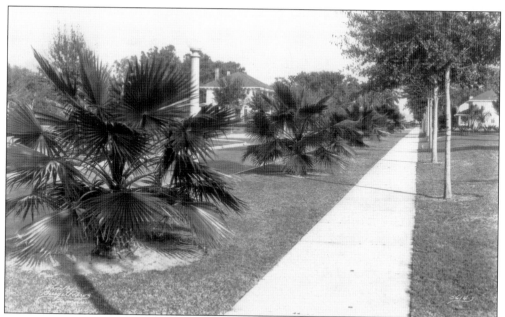

Cabbage palms and recently planted swamp oak seedlings flank both the tree lawn and sidewalk in this view of a Harbor Oaks main thoroughfare from around 1924. Judging by the size of the horticulture and the number of homes in the background, one can clearly see that more than 10 years of development had been completed at this time. (Courtesy of the Tampa-Hillsborough County Public Library System—Burgert Bros. Collection.)

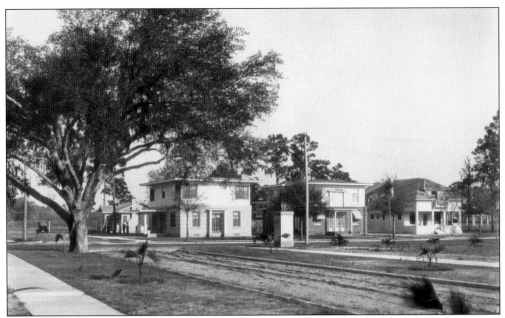

Alvord communities were distinct in their use of innovative design features to accommodate basic development infrastructure such as utilities. In this photograph, which shows several homes on the east side of South Fort Harrison at its intersection with Jasmine Way and dates to around 1920, the roadbed visible in the lower right more than likely was utilized as an access road or even a horse path to enable local workers to transport supplies or address service requests. (Courtesy of the Tampa-Hillsborough County Public Library System—Burgert Bros. Collection.)

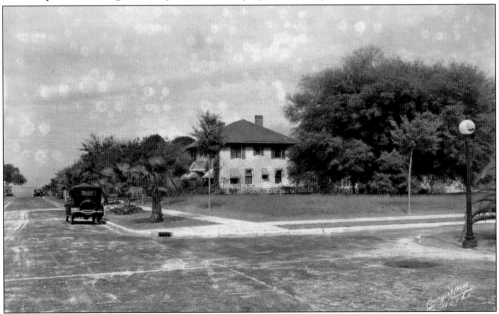

Alvord communities were noted for their streamlined incorporation of community infrastructure, such as utilities, into the overall design. This c. 1921 photograph of 322 Magnolia clearly shows this integration as all utilities are buried underground. (Courtesy of the Tampa-Hillsborough County Public Library System—Burgert Bros. Collection.)

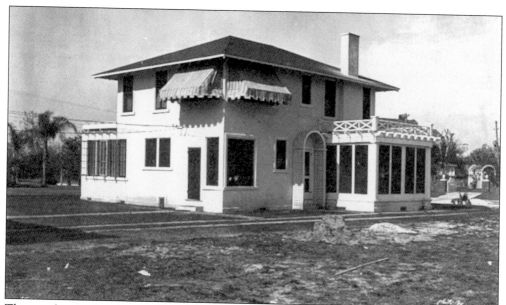

This nearly completed structure in Harbor Oaks, pictured around 1924, features both a sunroom in the front and a screened room with upper balcony in the rear. Note the two large awnings flanking the northeastern and southern exposures of several upper-story windows. These design elements not only protected bedroom areas from receiving too much light but also provided a finishing touch to what otherwise would be a simple, basic home design. (Courtesy of the Tampa-Hillsborough County Public Library System—Burgert Bros. Collection.)

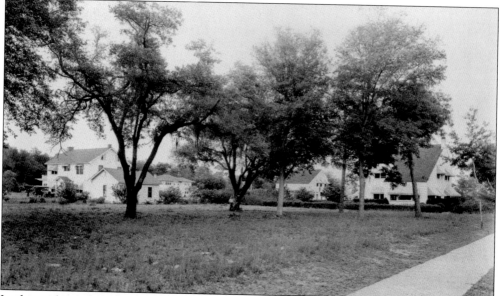

In this wide-angle 1924 shot of Magnolia Drive (414 Magnolia can be seen to the right), the majestic swamp oaks that are native to the Florida peninsula are clearly visible, as are several modest homes in the area. Alvord's emphasis on horizontal frontage is very evident, as is his insistence that development improvements (in this case, sidewalks) be neat and free of debris, even in front of vacant lots. (Courtesy of the Tampa-Hillsborough County Public Library System—Burgert Bros. Collection.)

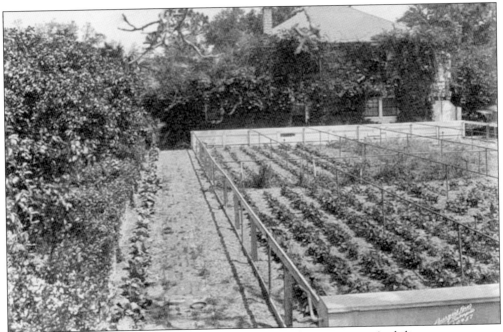

One of the distinguishing aspects of Harbor Oaks is the community's ability to appear as a sophisticated, urban neighborhood while at the same time paying homage to its agrarian roots as a former orange grove owned by the pioneering McMullen family of Clearwater. (Courtesy of the Tampa-Hillsborough County Public Library System—Burgert Bros. Collection.)

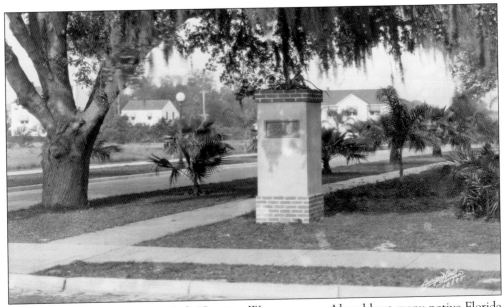

In this 1924 picture of Harbor Oaks' Jasmine Way entrance, Alvord kept many native Florida landscape elements intact. The overall effect that Alvord tried to achieve for the planned community concept is well represented here. (Courtesy of the Tampa-Hillsborough County Public Library System—Burgert Bros. Collection.)

Waterfront properties in Harbor Oaks took advantage of Alvord's decision to size most standard lots as double lots. This image shows how both native and manicured vegetation were incorporated into bay-front landscapes—capitalizing on wide, horizontal layouts and corresponding deep, vertical lot dimensions to create both waterfront-vista and terracing opportunities. In the distance is Caladesi Island. First inhabited by Tocobaga Indian tribes, it was later occupied by Spanish explorers around 1530. Cartographers finally listed it as Sand Island in the 1830s. Henry Scharrer, a developer, named it Hog Island in 1890. A 1921 storm split the island in half. The southern half became known as Caladesi Island, named after an 18th-century Spanish fisherman, Cayo de Calders, who camped there. (Courtesy of Heritage Village.)

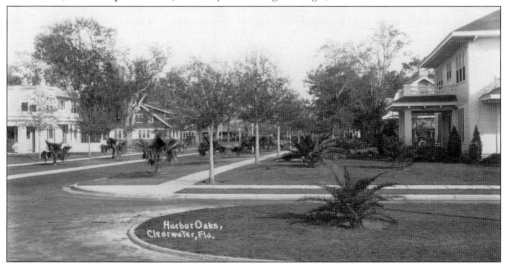

The existence of green space in Alvord communities was always evident; this photograph of the corner of Bay Avenue and Druid Road West in Harbor Oaks, taken sometime between 1921 and 1924, is no exception. The Frank Booth house appears to the left, and the home of John D'Homerque can be seen to the right. Also note the evidence of ambient lighting in these spaces. (Courtesy of the Tampa-Hillsborough County Public Library System—Burgert Bros. Collection.)

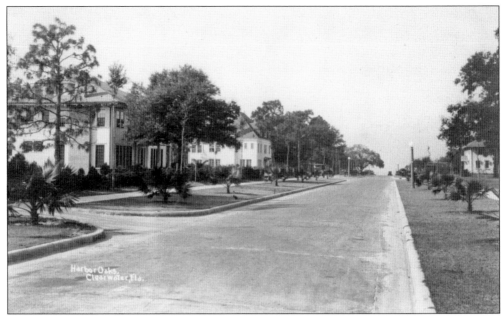

This interesting Magnolia Drive view from around 1922 shows Alvord's ability to make landscapes and community infrastructure become the focal points of the development. Alvord had been one of the first to introduce the boulevard concept in his Jamaica Queens and Long Island communities. (Courtesy of the Tampa-Hillsborough County Public Library System—Burgert Bros. Collection.)

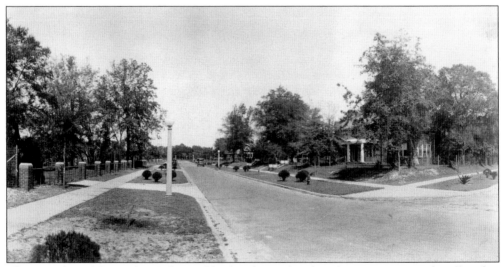

This 1924 shot of the Harbor Oaks neighborhood provides a bit of perspective as to the effect that Alvord's placement of ambient lighting had on the development as well as evidence of some of the land elevations that were incorporated into the community plan in order to address storm water management (through water-flow and water-routing techniques). (Courtesy of Frank Hibbard.)

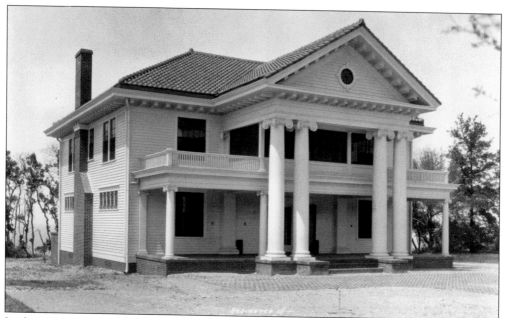

In this 1919 photograph, the gothic columns and balcony associated with an antebellum design are clearly visible. This is the recently completed home of Titanic survivor Emma Bucknell, situated on one of the bayside Druid South lots as indicated by the elevation, which appears to be slightly above street level. Note the lack of vegetation beyond a short tree/brush line to the rear of the property. (Courtesy of the Tampa-Hillsborough County Public Library System—Burgert Bros. Collection.)

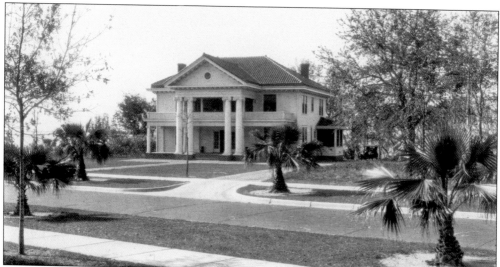

This picture shows the Bucknell house as it appeared in 1921, its Gothic columns clearly visible. In a 1985 *St. Petersburg Times* article titled "Housewife Protests House's Destruction," countryside resident Bridget Phillips protested the plans of homeowners Harold F. and Diane Heye to tear down the Emma Bucknell house (which had belonged to the longtime widow and third wife of William Bucknell, founder of Bucknell University in Pennsylvania). Soon after the article was published, the home was demolished by a reluctant crew. (Courtesy of the Tampa-Hillsborough County Public Library System—Burgert Bros. Collection.)

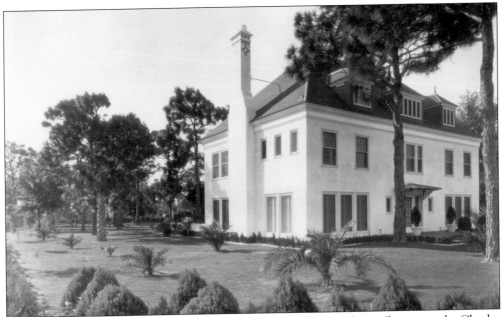

The dramatic angle of this 1921 photograph of a French Provincial home (known as the Charles Spence house) built in 1920 shows how Alvord's attention to detail architecturally enables the builder to incorporate nontraditional design cues into the structure, such as the unusual tiling at the tip of the chimney cap. (Courtesy of the Tampa-Hillsborough County Public Library System—Burgert Bros. Collection.)

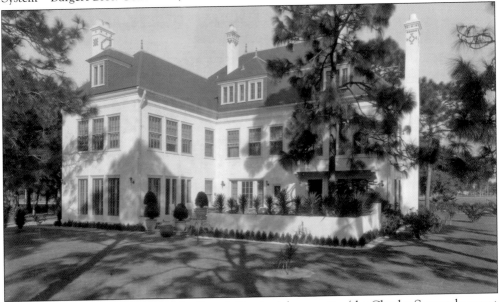

This back and side view of one of the French Provincial properties (the Charles Spence house at 315 Magnolia) gives the viewer a sense of the stylistic transition from native Florida to traditional French Provincial (with Spanish Mediterranean influences)—particularly when looking at the three chimneys' intricate terra-cotta tile inlays. Both the two main outer fireplaces and the supplemental inner fireplace feature these additional features. (Courtesy of the Tampa-Hillsborough County Public Library System—Burgert Bros. Collection.)

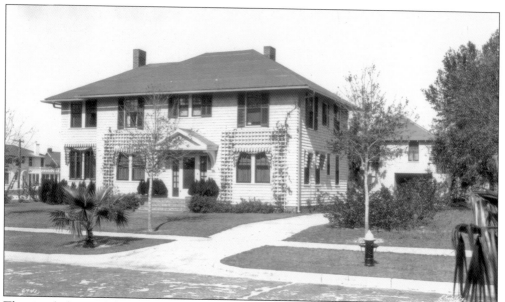

The simple lines of this Colonial Revival home at 322 Magnolia Drive, photographed in the mid-1920s, represent the quintessential mix of traditional and Florida-centric elements that Alvord wished to emphasize in the development. Landscaping using both native and nonnative species (such as the Queen Palms juxtaposed with evergreen shrubbery) flanks the main entry and curb-strip area (known in some parts of the United States as the "devil strip" based on the fact that homeowners do not technically own it but are required to maintain it). Current owners report that members of the Ingersoll family once owned this property. (Courtesy of the Tampa-Hillsborough County Public Library System—Burgert Bros. Collection.)

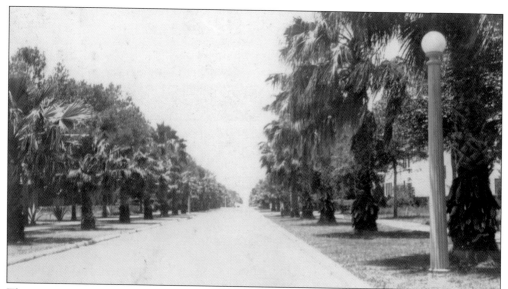

This view from Magnolia Drive illustrates the efficient use of native landscape design to create a manicured yet tropical effect. Note the use of period lighting at the right of the photograph. (Photograph courtesy of Frank Hibbard.)

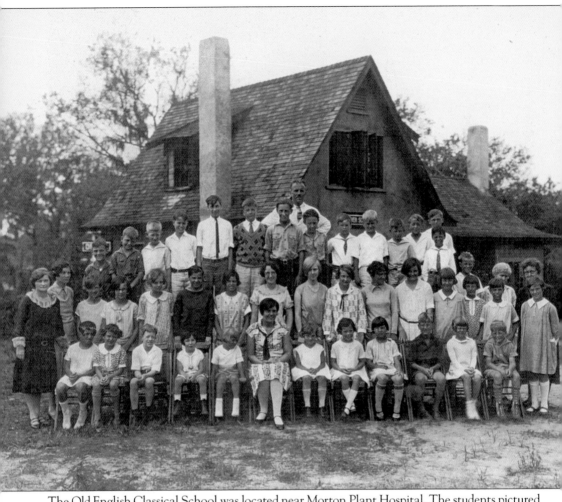

The Old English Classical School was located near Morton Plant Hospital. The students pictured here around 1927 include well-known Clearwater automobile dealer Larry Dimmitt Jr. and his sister Dorothy Dean Dimmitt. They are joined by Professor Hoare (standing centered in the back), the headmaster who started the famous "open air" school under a banyan tree in St Petersburg. Hoare's son Dr. Francis Hoare became a noted Morton Plant Hospital physician. (Courtesy of Michael L. Sanders.)

Industrialist William Cooper Procter (Procter & Gamble chief executive officer), seeking warmer climates for his lung condition, purchased 311 Magnolia Drive in 1932. Procter was noteworthy for his kind treatment of employees, including instituting profit sharing and half-day Saturdays. His letters to niece Mary Johnston confirm that he spent the winters of 1933 and 1934 in the home before dying in Cincinnati in 1934. Subsequent to Mary Jane E. Procter's death in 1953 at the age of 90, the home was bequeathed to Mary Johnston. Johnston owned it until her death in 1967, at which time the property passed to the Presbyterian Church of the Ascension. (Courtesy of Michael L. Sanders.)

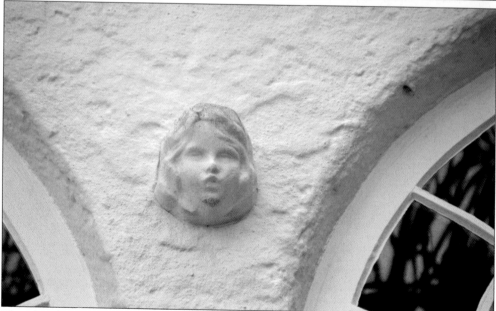

This cherub is associated with, "Casa Del Mar," 423 Magnolia Drive, which Robert S. Brown (of Century Oaks) built in 1925 for his daughter Mae Brown Savage. She and husband John owned the home until 1945. This design is flanked by arched windows, original to the structure. A cherub is a type of spiritual being discussed in the Hebrew Bible and in Christian biblical canons as indicating the presence of God in a space. (Courtesy of Karl Scheblein.)

The John "Jack" M. Studebaker III house seen here c. 1931 was completed in late 1925 and featured numerous Mediterranean Revival architectural details, including a custom Cuban-style barrel-tile roof; a U-shaped open-to-sky central courtyard; basket-weave, imported tile floors; and a large fireplace in the living room (which served as a focal point of the home). In addition, Donald Alvord directed contractors to apply stucco over terra-cotta hollow block structural walls. In the 1960s–1970s, the exterior of the home was covered with vines, giving it an unusual, three-dimensional appearance. Studebaker, from South Bend, Indiana, was the grandson of John Mohler Studebaker—one of five brothers who started the Studebaker Corporation, which began building carriages in the early 1800s and was later one of the largest independent automobile producers in the United States until the company's demise in the 1960s. (Courtesy of the Cooper family collection.)

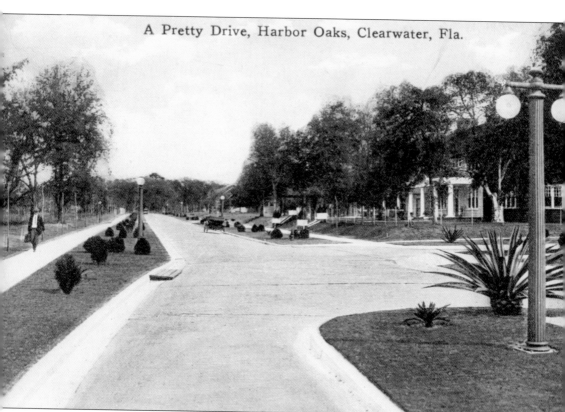

One can truly appreciate the detail associated with the infrastructure Dean Alvord designed into his communities from both the visual and verbal content associated with this photograph looking north from the corner of Druid Road South. The Harbor Oaks brochure refers to the overall effect, saying, "Roadways are paved with 'asphelete' and sidewalks and curbs are laid in dark concrete to avoid the glare [from the intense Florida sun]." (Courtesy of the Harold Wallace Estate.)

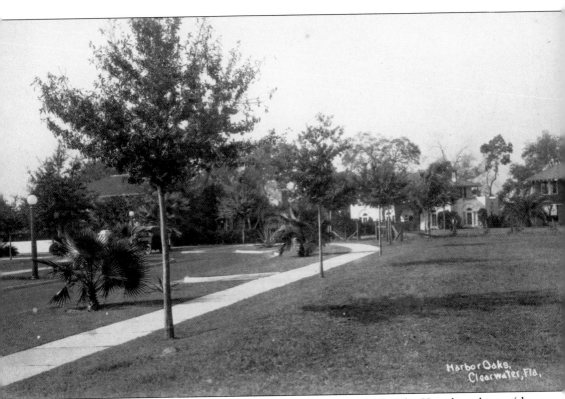

Harbor Oaks,
Clearwater, Fla.

This image shows Druid Road as it transitions from west to south. The Kingsbury home (the white structure positioned straight ahead) and the Brown Estate (positioned to its left) are clearly visible. It appears that the Kingsbury home had not yet been incorporated into Brown Estate at the time of this photograph, taken around the mid-1920s. (Courtesy of Heritage Village.)

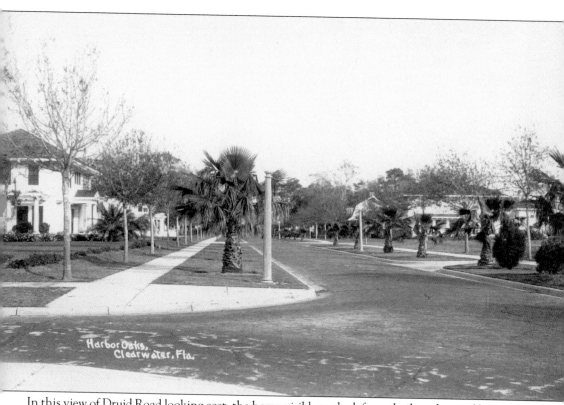

In this view of Druid Road looking east, the home visible to the left was built and owned by Dean Alvord in 1918 shortly after he sold his Druid waterfront estate to Kodak executive Edmund Lyon from Rochester, New York. (Courtesy of Heritage Village.)

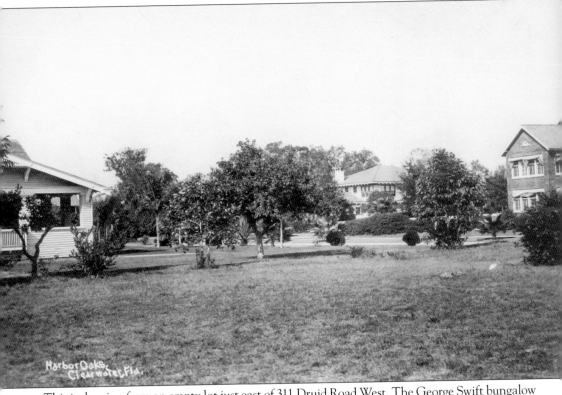

This is the view from an empty lot just east of 311 Druid Road West. The George Swift bungalow is visible to the left, and the Robert S. Brown Estate can be seen ahead in the distance. To the right is author Sewell Ford's home. Note all the fruit trees, which were left undisturbed during development and construction of these three homes—all built between 1913 and 1915. (Courtesy of Heritage Village.)

Four

ARCHITECTS AND FEATURED HOMES OF HARBOR OAKS

Even though Dean and Donald Alvord developed Harbor Oaks and personally selected some of the design features that accompanied many of the homes constructed there, a number of talented architects designed and, in some cases, were involved in the construction of Harbor Oaks homes. These professionals are considered by Tampa Bay and Florida historians to be some of the most prolific and successful architects of the region and state.

The most accomplished architect whose designs were used to construct homes in the Harbor Oaks community was Francis J. Kennard—already famous for having designed the largest wood-framed building constructed in Florida at the time (the Hotel Belleview and Cottages in Belleair, designed with architect Michael J. Miller and built in 1896); the hotel was later known as the Belleview Biltmore Hotel.

A notable Kennard-designed residence in Harbor Oaks is the John Mohler ("Jack") Studebaker III home at 415 Magnolia Avenue. Studebaker commissioned Alvord to build the Mediterranean Revival home on a lot purchased from Alvord's Harbor Oaks land inventory. It was completed in late 1925 and reflected the 28-year-old owner's prominence as a well-known member of the Studebaker family, whose firm's involvement in vehicle manufacturing (carriages, automobiles, and trucks) dated back to the early 1800s.

Another highly regarded Harbor Oaks architect was John Phillipoff, the principle designer and builder of the Booth residence at 410 Druid Road West. This iconic Harbor Oaks residence was built for Clearwater mayor Frank J. Booth in 1923. Booth, a commercial realtor based in Clearwater's downtown area, served as mayor from 1920 to 1926.

Yet another noted Harbor Oaks–area architect was Roy Wakeling who designed Spottis Woode, or Spottiswoode—the classic Tudor mansion owned by inventor Donald Roebling whose great-grandfather John Roebling and grandfather Col. Washington Roebling designed and built (respectively) several notable bridges in the United States, the Brooklyn Bridge being among the most famous. Donald Roebling was also famous in his own right for designing the Landing Vehicle Tracked (LVT) also known as the "Alligator" amphibious military vehicle that was used extensively throughout World War II.

Wakeling designed many of the homes in Belleair Estates and was principal architect for famed developer Walter Fuller, whose Jungle Hotel (now Admiral Farragut Academy) was a popular resort hotel constructed in St. Petersburg during the Florida Land Boom of the 1920s. Similarly, Wakeling also designed estate homes on St. Petersburg's Snell Isle development and worked for "Handsome" Jack Taylor on the design of another famous Florida Land Boom-era hotel, the Roylat (currently the Stetson University College of Law), located in the St. Petersburg enclave of Gulfport.

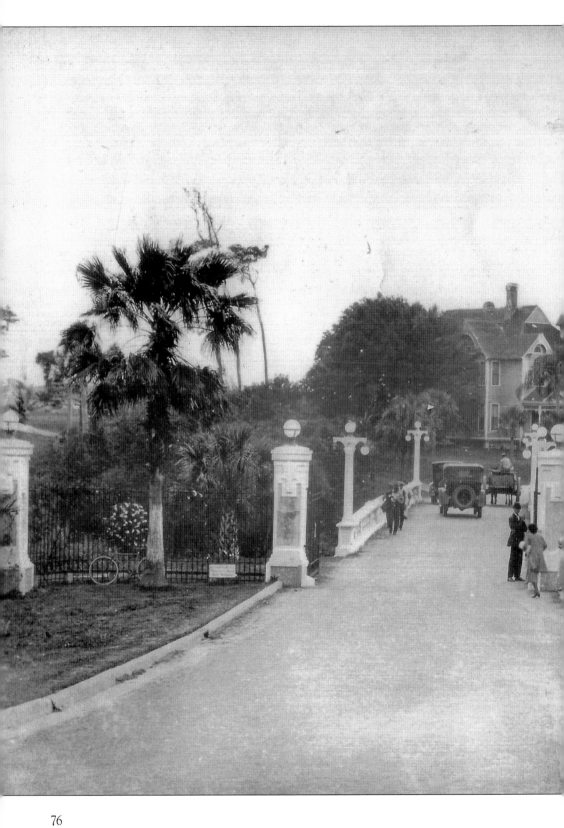

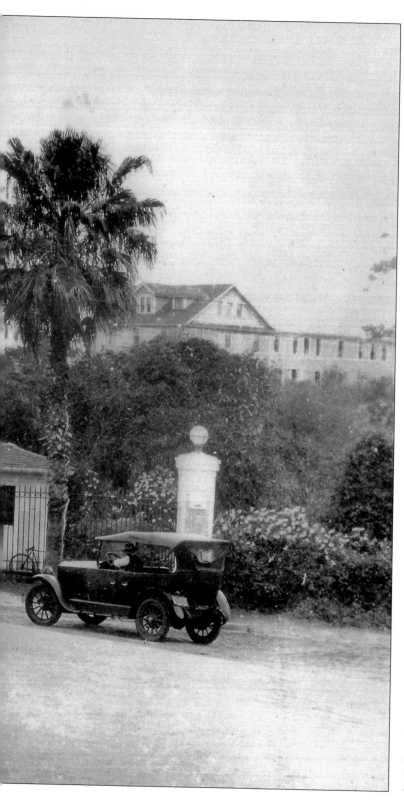

Flanked by stone entry pillars and Victorian lighting, this 1920s-era picture of the entrance to the Hotel Belleview (later known as the Belleview Biltmore Hotel) shows evidence of the land elevation and layout of the "White Queen of the Gulf," as the structure came to be known. Other interesting features visible in this photograph include several "native" gardens and the guard station where visitors were greeted and had their credentials and reservations checked. (Courtesy of Frank Hibbard.)

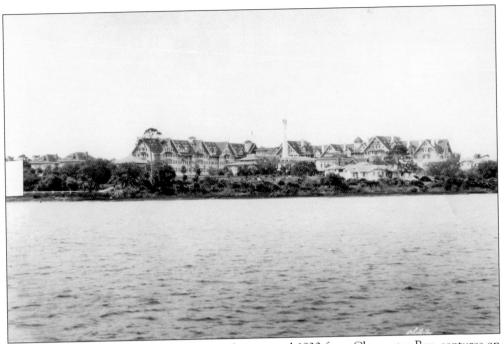

This photograph of the Hotel Belleview, taken around 1930 from Clearwater Bay, captures an expansive vista of one of the crown jewels in industrialist Henry Plant's hotel empire. The property's sheer size, as well as its location atop one of the bluffs that dot the Intracoastal Waterway, is well represented here. (Courtesy of Frank Hibbard.)

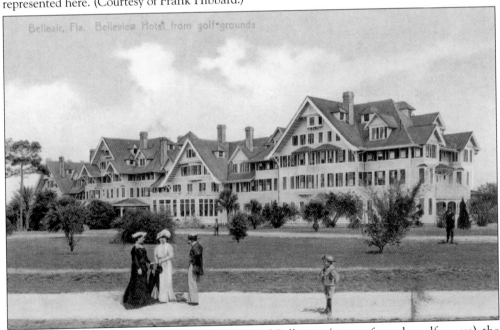

In this stylized postcard view of Henry Plant's Hotel Belleview (as seen from the golf course), the expansive roof gables and wide eaves (both of which became noted Harbor Oaks architectural design elements) are clearly visible. The hotel originally had three main wings and a large ballroom/grand-hall area in the center. (Courtesy of Heritage Village.)

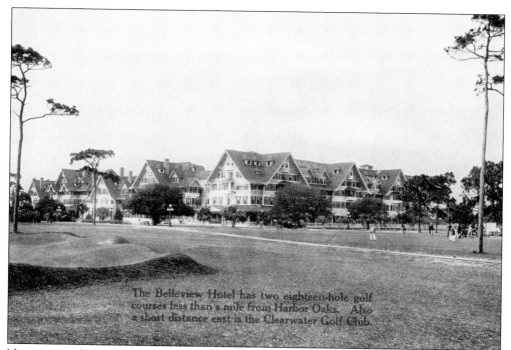

The Belleview Hotel has two eighteen-hole golf courses less than a mile from Harbor Oaks. Also a short distance east is the Clearwater Golf Club.

Numerous architects designed homes in Harbor Oaks; the most notable of these was Francis J. Kennard. This view of the Hotel Belleview highlights the expansive wooden porches and wide roof fascias Kennard used. (Courtesy of the Harold Wallace Estate.)

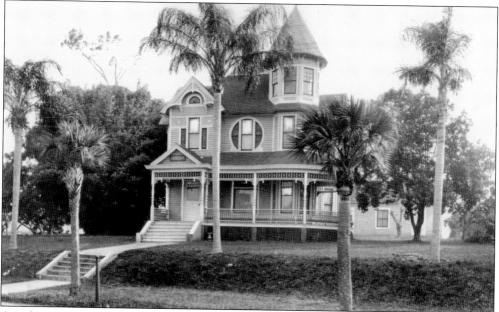

Another "cottage" home (pictured around 1930), this Victorian-style residence features an integrated octagonal tower as well as circular shutters and windows. They were in close proximity to the Henry Plant Railroad's side tracks, which wealthy residents used for entry either to the neighborhood where cottage homes like Eastgate were located or to the main Hotel Belleview complex. (Courtesy of Frank Hibbard.)

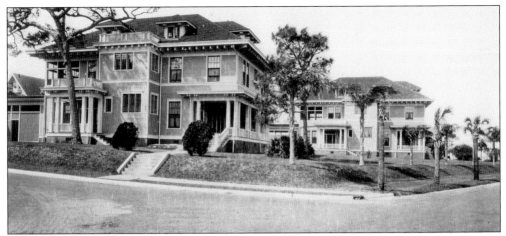

Two of the cottage homes that were part of the Hotel Belleview complex—the Magnolia and Brightwater Cottages—are seen in this c. 1930 photograph. Designed to mimic the Victorian-cottage themes of the main 260-room hotel, they feature its characteristic covered porches, planked eaves, and turned posts/banisters. Built by G.M. Miller, these structures typically sat on double lots like those in Harbor Oaks, and like Harbor Oaks homes, they were private Estate-size residences despite being called "cottages." (Courtesy of Frank Hibbard.)

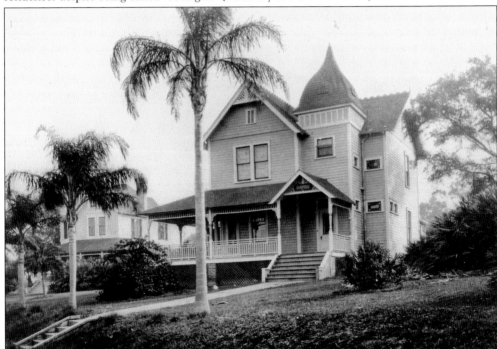

In this view of what was named the Bayou Cottage, the home's traditional Victorian lines are abruptly interrupted by the inclusion of an onion-shaped crown on the rectangular tower that forms the structure's foyer area. It is interesting to note that while the Victorian-cottage design proved to be very popular in the communities surrounding the Hotel Belleview, very few homes in Harbor Oaks chose this style of architecture—evidence of Dean Alvord's preference for Estate-style designs and the traditional structural techniques of the northern United States. (Courtesy of Frank Hibbard.)

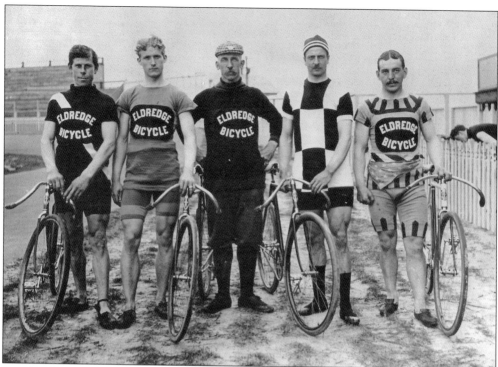

Bicycle athletes from the Eldredge Bicycle Club of Great Britain (1898) pose here in between races, which proved popular at the Belleview from 1898 until around 1914. The bicycle track was composed of oyster shells, according to the Pinellas County Historical Museum and Heritage Village, and after 1914 it became part of one of the Hotel Belleview's golf courses. (Courtesy of Heritage Village.)

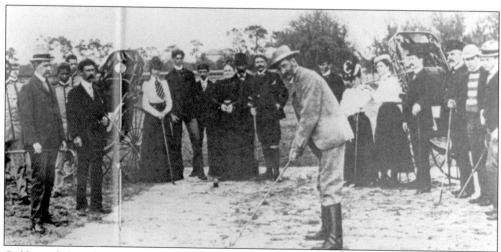

Golf was definitely a popular sport for Florida's winter residents, and in this early shot of famed railroad tycoon Henry Plant at a golf outing held at his Hotel Belleview, both men and women can be seen participating. Plant is teeing off on one of the six original golf holes built near the hotel complex. Note the wardrobes as well as the primitive conditions of the greens and tee boxes. In the background, African American caddies await requests to provide assistance to the golfers. (Courtesy of the Harold Wallace Estate.)

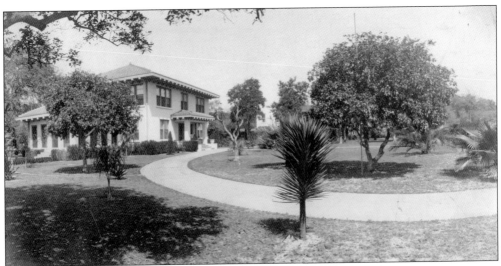

The first home Dean Alvord built in 1913–1914 was a Colonial Revival–design stucco structure. It was sold in 1922 to Robert S. Brown—the producer of japan black paint, which was used exclusively on the Ford Model T—who expanded the home to the north and south. It initially had a footprint of more than 16,500 square feet and palatial gardens featuring a campanile tower. During the 1920s and 1930s, musical concerts were held on Wednesday evenings, and Clearwater residents parked and listened to the music emanating from the campanile. (Courtesy of Heritage Village.)

A plaque commemorating Fort Harrison was constructed and embedded into the wall of Robert S. Brown's Century Oaks Estate around 1925. It indicates that one is standing on the highest bluff on the Florida Gulf Coast. Century Oaks was purchased from Dean Alvord by Edmund Lyon (an executive for Kodak), who in turn sold it to Robert S. Brown in 1922 for $90,000. (Courtesy of Heritage Village.)

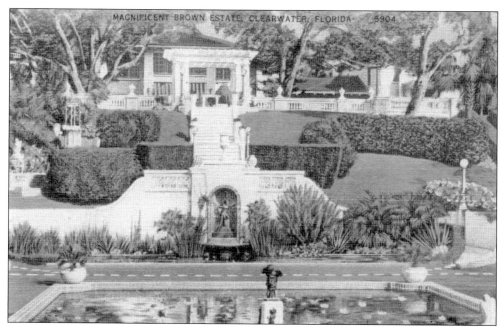

This artist's rendition of the Robert S. Brown Estate (Century Oaks) shows the magnificence of the grounds and structures that graced the rear of the property. The upper trellis and concrete railing lead down to the lower landing, with integral fountain and statuary fronting the pond. Note the terracing of the landscape as well as the ambient lighting that surrounded the space. (Courtesy of the Harold Wallace Estate.)

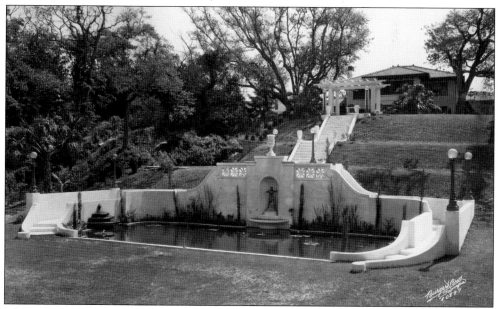

Edmund Lyon from Rochester, New York, acquired Dean Alvord's Colonial Revival home at 802 Druid Road and renamed it "Century Oaks" in honor of the century-old live oaks that shade the estate. This c. 1924 view shows the sizable Greek pergola and bronze statuary that were added by subsequent owner Robert S. Brown in the rear of the property, which also overlooks Clearwater Bay. (Courtesy of Michael L. Sanders.)

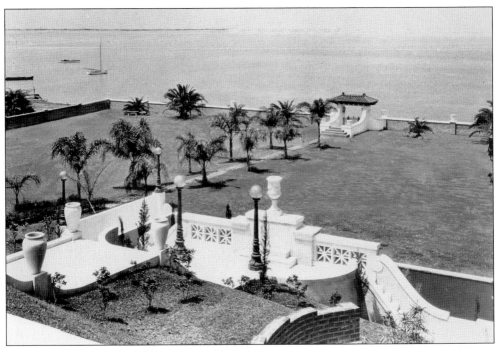

Here is another c. 1924 view of the Robert S. Brown Estate at 802 Druid Road. This image profiles the elaborate gardens as a work in progress to the west of the main house. Note the native landscaping as well as the terracing associated with the site's location on the bluff. (Courtesy of Michael L. Sanders.)

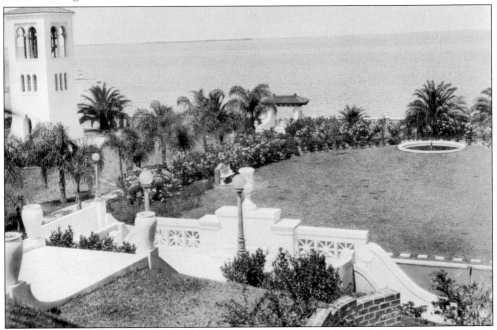

This c. 1926 bayside view of Century Oaks profiles the recently completed carillon tower and terraced gardens with fountains. Robert S. Brown, developer of one of the versions of the japan black paint used on millions of Ford Model Ts, bought the home for $90,000 in 1922 and invested an additional $990,000 to expand the estate. (Courtesy of Heritage Village.)

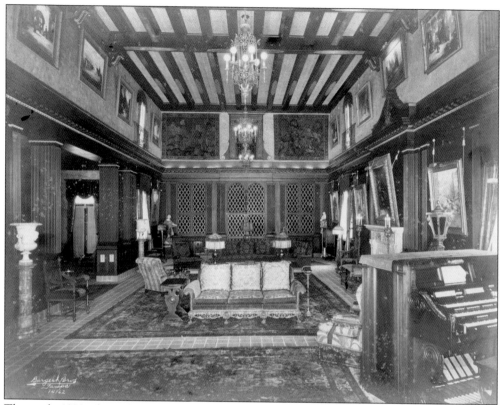

This early 1930s shot of the music room/wing of the Robert E. Brown residence illustrates the opulence associated with many of the estate-style properties in Harbor Oaks. Built exclusively to house the Detroit, Michigan–made large pipe organ shown in the lower right corner, the mahogany carvings and ceiling beams are accented with Renaissance artwork and other embellishments. Brown enjoyed playing the organ and also conducted outdoor bell concerts each week during the winter at 8:00 p.m. (Courtesy of the Harold Wallace Estate.)

This wide-angle view of the interior of Century Oaks features some of the structural details of the more than 16,000 square feet of interior living space. The ornate artwork and furnishings reflect the move by the rich of America's Gilded Age of the early 20th century to mimic styles and tastes of the Renaissance. (Courtesy of Heritage Village.)

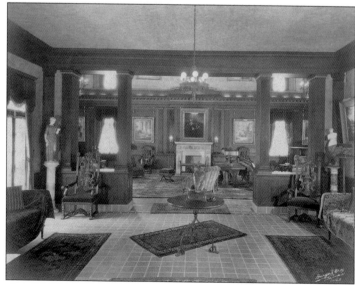

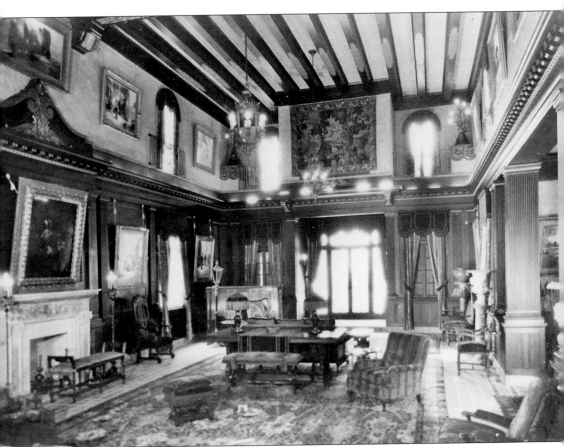

Here is another view of the music room located in the south wing of the Robert S. Brown residence, once again illustrating the opulence associated with many of Harbor Oaks' estate-style properties. In this view, the mahogany carvings and ceiling beams are clearly visible. (Courtesy of the Harold Wallace Estate.)

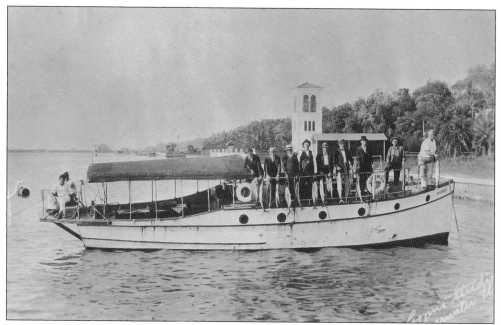

During the early years of the 20th century, fishing for sport was an emerging enterprise, with boat captains taking groups of winter residents and wealthy visitors on daylong excursions in Clearwater Bay and the Gulf of Mexico. One such expedition from the late 1920s is pictured here. Note the formal attire worn by the participants. Part of the Brown Estate bell tower, or campanile, is visible in the background. (Courtesy of Michael L. Sanders.)

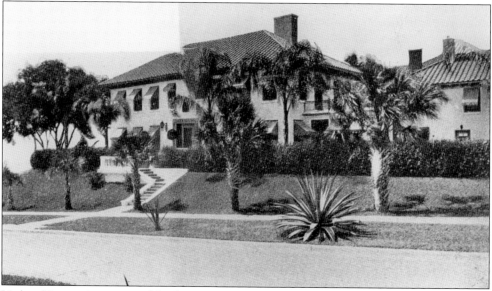

Herbert Harrison's unexpected death in 1927 prevented him and his wife, Florence, from completing construction of 205 Magnolia Drive. Subsequently, Donald Alvord designed a smaller speculation home at 208 Magnolia Drive (pictured here) that incorporated several of the same grand Mediterranean Revival features intended for the 205 Magnolia Drive residence. Construction of this home began around early 1928 and was probably completed in early 1929. Florence Harrison, now a widow, purchased this home soon after it was completed. (Courtesy of Frank Hibbard.)

The Harrison Harbor Oaks home (208 Magnolia Drive) in Clearwater was bought by Florence Maria Harrison—the widow of Herbert Champion Harrison—sometime after the 1927 death of her husband that occurred during a business trip to England. Based on the letters that were exchanged between Florence and home-seller Dean Alvord, it appears that Alvord was initially reluctant to deal with a woman in a real estate transaction but ultimately found her quite capable of conducting business on her own. (Both, courtesy of Michael L. Sanders.)

These photographs of the Harrison Estate at 208 Magnolia provide a good perspective as to its bluff location and overall design. The barrel-tile roof of both the main structure and the carriage house is clearly visible, as are the window awning treatments located on the upper sill of each front-facade window. Florence Harrison lived in the home until the 1940s, after which ownership was passed to her son. (Both, courtesy of Michael L. Sanders.)

89

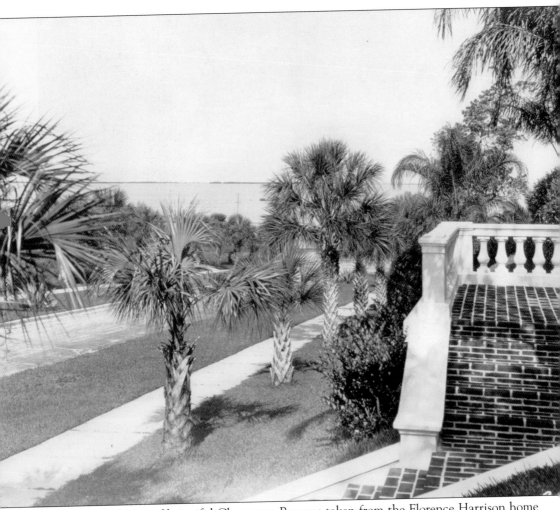

This westward view of beautiful Clearwater Bay was taken from the Florence Harrison home at 208 Magnolia Drive, which was completed between 1928 and 1929. Herbert Harrison was a pioneer in the automobile industry, having founded the Harrison Radiator Company (later the Delphi Automotive Group) in Rochester, New York, but he died in 1927, well before completion of this home. (Courtesy of the Cooper family collection.)

This shot of Donald Roebling was taken around 1924 in the garden area at his parents' home in Bernardsville, New Jersey. John Roebling II, his wife, and son Donald (born in New York City in 1908) lived on this estate. Donald's father, by this time, primarily managed the Roebling family fortune, leaving the running of the Roebling engineering and construction business to other family members. (Courtesy of Heritage Village.)

Another shot of the Roeblings—Donald and his parents—shows them enjoying a morning breakfast out on the patio area of the Roebling Estate in Bernardsville, New Jersey. Strong willed and temperamental, Donald was a poor student and became very overweight later in life; yet, his contributions to the World War II effort—through the development of the LVT Alligator amphibious vehicle—are noteworthy, as was the creation of his Clearwater estate, Spottis Woode. (Courtesy of Heritage Village.)

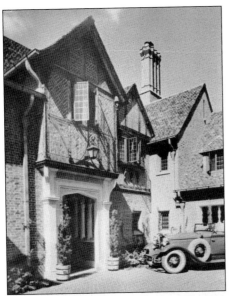

Construction began on Spottis Woode in 1929, and the main structure was completed in 1931. Significant exterior construction details include the use of steel beams, precast gypsum, block-roof decking (tongue-in-groove style), brick facade, and 18-inch wall thickness—intended to "last three generations," according to Donald Roebling. Special Ludowici flat tile from Ohio adorned the original roof; the tile was also used on an umbrage built around the front entry, which housed a solid wood door. (Courtesy of Michael L. Sanders.)

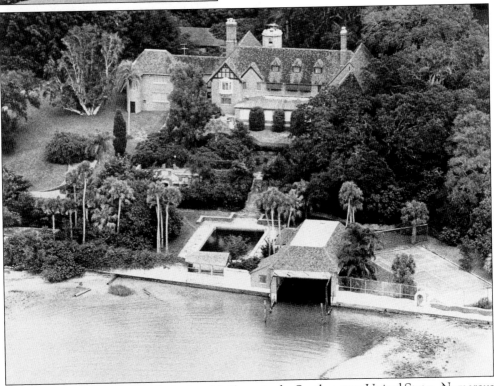

Spottis Woode is situated on the highest bluff area in the Southeastern United States. Numerous southern live oak trees (some of which are estimated to be nearly 400 years old) adorn the grounds. Roy Wakeling—who has been identified as the major architect of luxury homes in the Tampa Bay area during the 1930s and 1940s—included unique design details, such as hand-painted exterior tiles that each contained a unique painting of a mammal, bird, fantasy character, or other elements. This feature extends to the boathouse, where nautical themes grace the tiles used on that structure. (Courtesy of Michael L. Sanders.)

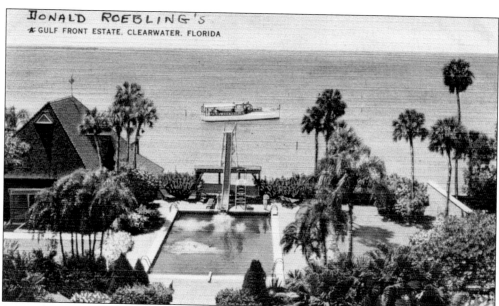

DONALD ROEBLING'S
A GULF FRONT ESTATE, CLEARWATER, FLORIDA

Spottis Woode is the name given to the classic Tudor mansion owned by inventor Donald Roebling, whose great-grandfather John designed and built several notable bridges in the United States, including the Brooklyn Bridge and the Niagara Falls Suspension Bridge as well as others in the northeastern United States. Donald Robeling was notable in his own right for designing the LVT Alligator amphibious military vehicle, which was used extensively throughout World War II and for which he was presented the prestigious Medal of Merit signed by Pres. Harry S. Truman in 1948. (Courtesy of Michael L. Sanders.)

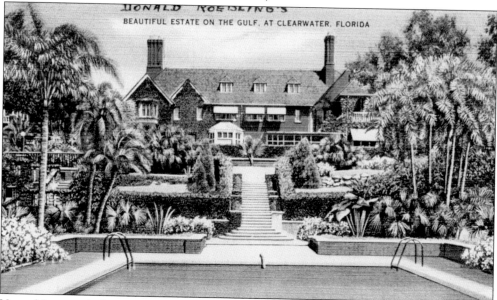

DONALD ROEBLING'S
BEAUTIFUL ESTATE ON THE GULF, AT CLEARWATER, FLORIDA

Viewed from poolside, Spottis Woode can be seen from the rear. The home covers nearly 17,000 square feet and has 40 rooms on seven acres of land. Construction began in 1929 and was completed on the main residence in 1931 at a cost of more than $600,000—a sizable sum at the time. On his 21st birthday, in 1929, Roebling inherited $5 million, which provided the capital to begin the development of Spottis Woode. (Courtesy of Michael L. Sanders.)

Architect Roy Wakeling's innovative use of unique design elements is carried inside Spottis Woode, where eight carved oak newel posts on the second-floor banister feature likenesses of the skilled craftsmen who constructed the house (each holding the representative tool of his trade). This photograph offers a glimpse of Spottis Woode's library with marble fireplace. Incidentally, the main fireplace is divided above into six geometric sections, each containing crests from Donald Roebling's first wife, Florence Spottis Woode Parker—the estate's namesake. (Courtesy of Michael L. Sanders.)

In this photograph of one of the newel posts anchoring the handrail on the second floor banister of Donald Roebling's Spottis Woode Estate, Roy Wakeling's own likeness is depicted holding an architect's square ruler. A sculptor from New York City was commissioned to carve the eight tradesmen's images—architect, builder, head foreman, plasterer, surveyor, carpenter, plumber, and electrician. (Courtesy of Heritage Village.)

Here is another view of one of Roy Wakeling's architectural features, a newel post featuring Clearwater plumber Ralph A. "Gus" Gourieux. This is one of eight carved oak newel posts on the second-floor banister that feature the carved likeness of each of the craftsmen who constructed the house. These newels are a testament to Wakeling's talent as a designer and his ability to incorporate unique elements into his designs. (Courtesy of Heritage Village.)

In this picture, Donald Roebling's just-completed yacht sits in dry dock, flanked by its construction crew, with Roebling himself standing in the middle of the rear group (seventh from the left). Roebling was known to enjoy cruising Clearwater Bay and beyond while enjoying his trademark addiction to chocolate bars and sweets, part of his daily life of leisure that also included ham radio operation, mechanical tinkering, and stamp collecting. (Courtesy of Heritage Village.)

Donald Roebling's original 1935 LVT Alligator prototype was something of a failure as it was slow and heavy, and both the American Red Cross and the US Coast Guard turned down offers to buy it. The Model II Alligator was much more successful. Produced in 1936, it was able to reach water speeds approaching 5.75 miles per hour using a flathead Ford engine. (Courtesy of Michael L. Sanders.)

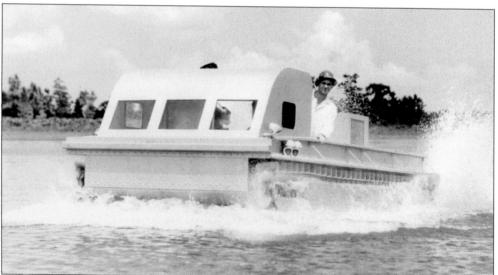

As Donald Roebling was producing the Model IV Alligator around 1937, the vehicle could frequently be sighted in St. Joseph Sound in the Gulf of Mexico, Clearwater Bay, and in the lakes and swamps of the greater Clearwater area. Interest grew nationally, and *Life* magazine profiled it in the science and industry section of its October 4, 1937, issue as a novel vehicle for "storm rescues." (Courtesy of Michael L. Sanders.)

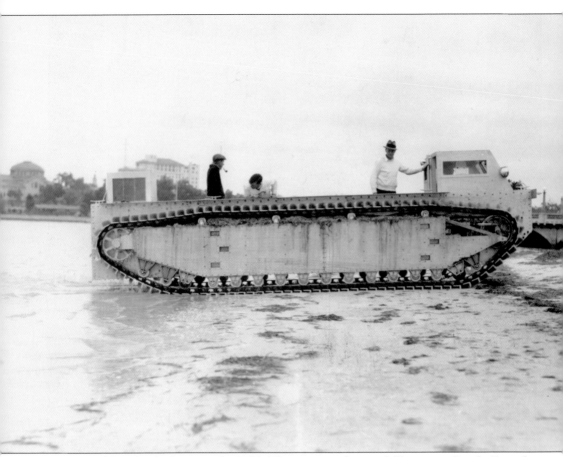

When Roebling finished testing the LVT Alligator in and around Clearwater Beach, Dunedin, and the Gulf of Mexico, the refined version could reach speeds of 29 miles per hour on land and 10 miles per hour in the water. Donald Roebling had previously built a workshop on Spottis Woode in 1935 and had hired six men to begin development of the Alligator; among the original group of engineers were Earl DeBolt, Warren Cottrell, and S.A. Williams. The vehicle was eventually mass-produced in Lakeland, Florida, by an established fruit-machinery manufacturer. This photograph shows Roebling (center) and several test engineers at low tide, probably in front of Spottis Woode around 1937. The Fort Harrison Hotel and Calvary Baptist Church are in the background to the north. (Courtesy of Heritage Village.)

After reading the article on Donald Roebling's LVT Alligator in the October 4, 1937 issue of *Life*, Marine Corps commandant Maj. Gen. Thomas Holcomb sent the write-up to a board that managed equipment procurement for the Marines. He directed board president Brig. Gen. Frederick L. Bradman to evaluate the Alligator and make a recommendation on the vehicle's possible use by the Marine Corps. (Courtesy of Michael L. Sanders.)

This is another view of Donald Roebling's versatile Alligator amphibious vehicle, which has been viewed by many military historians as one of the main contributors to both Pacific and Allied Forces' victories during World War II. Nearly 34 major missions involved the use of the Alligator, including numerous battles in the Far East, French Morocco, Belgium, and along the Rhine. In the midst of the war, Roebling and his Alligator were featured in a *TIME* magazine article in 1943. (Courtesy of Michael L. Sanders.)

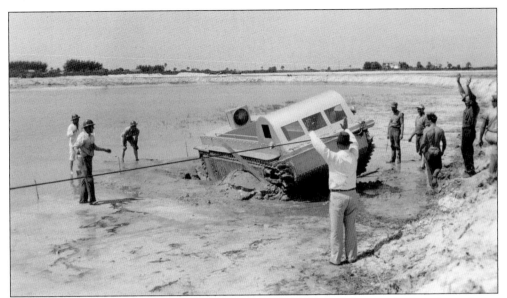

Here is an additional image of Donald Roebling's Alligator amphibious vehicle as it was being tested in and around Clearwater Bay (including on Caladesi Island/Honeymoon Island). Long prior to trials in open waters, Roebling had first tested the Alligator in his Olympic-sized pool at Spottis Woode for buoyancy and then in and around Lake Tarpon. The initial prototype weighed 14,350 pounds, was 93 feet long, and was powered by a 92-horsepower Chrysler engine. (Courtesy of Heritage Village.)

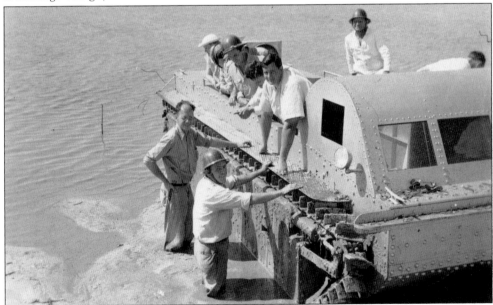

Roebling (in short sleeves, facing the camera) often supervised the testing as well as the troubleshooting of the LVT Alligator in the waters and spoil islands off Clearwater and Dunedin shores. Initial manufacturing at a plant in Dunedin, Florida, began to supply the Marines with Alligators. Additional contracts were promptly initiated with the Navy Department to fund the construction of other production facilities in Lakeland, Florida; Riverside, California; and San Jose, California. (Courtesy of Heritage Village.)

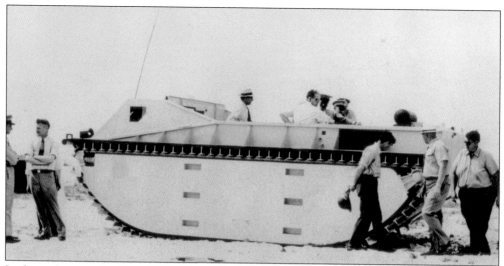

In these photographs, Donald Roebling's LVT Alligator is being tested in one of the swamp areas near Clearwater. This may have been part of the sub board of inspection and survey ordered by Brigadier General Moses to conduct the final testing of Roebling's first Marine Corps Alligator. After this phase was completed, the vehicle was sent to Norfolk, Virginia, for further testing. On October 31, 1940, the Alligator completed the Norfolk tests, and the Marine Corps finally received its first true amphibian at Quantico, Virginia, on November 4, 1940. (Courtesy of Heritage Village.)

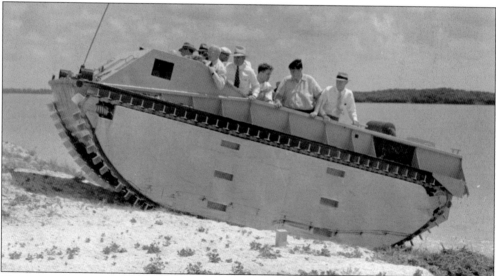

Numerous sources confirm that Donald Roebling's father, John Roebling II, who witnessed several destructive hurricanes in Central and South Florida during the 1920s, suggested to his son that he develop a vehicle that could be operated both on land and in aquatic environments to reach victims of such disasters. John Roebling offered to finance the development of such a vehicle. This c. 1941 photograph shows the Alligator being demonstrated on the beaches near Clearwater Harbor. To Roebling's left is chief engineer Bert Street, and the second man to Roebling's right with the hat is Clearwater resident and philanthropist Courtney Campbell, who would eventually become a US congressman. The Courtney Campbell Causeway that spans between Clearwater and Tampa Bay was named in Campbell's honor. (Courtesy of Michael L. Sanders.)

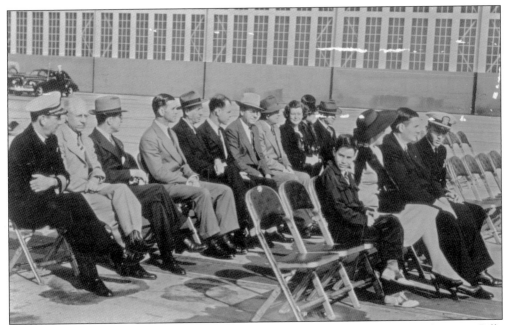

Here is a view of Donald Roebling seated in the first row with his second wife and stepson Billy Gilmore prior to receiving the Medal of Merit during a ceremony held in Jacksonville on February 15, 1947. Seated to Roebling's left is Rear Adm. Ralph Davidson, USN, Commandant of the Seventh Naval District. Signed by Pres. Harry S. Truman, the Medal of Merit was the highest civilian honor available at the time. Roebling's gracious donation of all of the patents associated with the LVT Alligator military amphibian tractor to the federal government turned out to be a sound business proposition as well as a grand gesture of duty to country. (Courtesy of Heritage Village.)

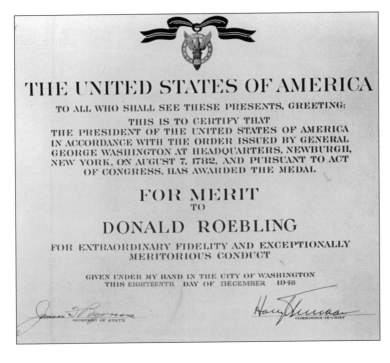

This certificate accompanied the Medal of Merit that Roebling received on February 15, 1947. He received the award for turning over all of the patents associated with his Alligator amphibious vehicle to the federal government. (Courtesy of Heritage Village.)

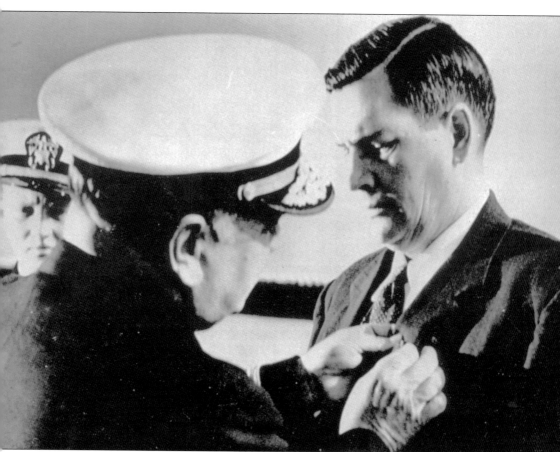

This photograph shows Donald Roebling and Rear Adm. Ralph Davison (left) as Roebling receives the Medal of Merit during a ceremony held in Jacksonville on February 15, 1947. Roebling was one of the earliest recipients of the Medal of Merit, which was originally created as part of Public Law 77-671, signed by Pres. Franklin D. Roosevelt on September 8, 1939. Both US and non–US citizens are eligible to receive the honor. (Courtesy of Heritage Village.)

This is a photograph of the Peace Memorial Presbyterian Church of which Donald Roebling was a member. It is located on South Fort Harrison Avenue in Clearwater, adjacent to the Harbor Oaks neighborhood. Founded in 1891 with 17 original members, this impressive Mediterranean Revival building was completed in 1922, with major renovations to the structure completed in 1956 and 1975. (Courtesy of Heritage Village.)

Here is a recent view of the Peace Memorial Presbyterian Church. Donald Roebling, following his receipt of the Medal of Merit for his work on the Alligator amphibious vehicle, helped fund the construction of what became Roebling Hall (building to the right) in 1956. He also contributed sizable sums of money to Morton Plant Hospital (where a wing was later named after him) and funded college educations for needy Boy Scouts in the Clearwater area. (Courtesy of Karl Scheblein.)

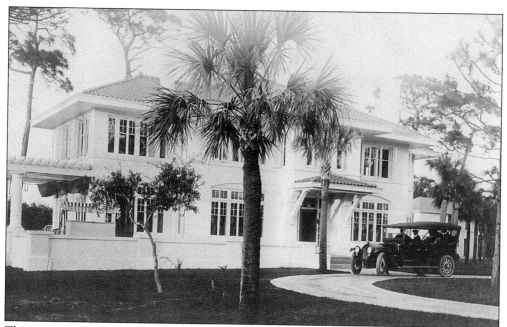

This impressive estate (built and photographed in the late 1910s)—a modified Colonial Revival design—clearly shows how Harbor Oaks' architects were able to artfully adapt traditional Florida construction materials and design techniques for use in other traditional architectural designs. The barrel tiles used on the main structure's roof and the portico roof are evidence of this. (Courtesy of Heritage Village.)

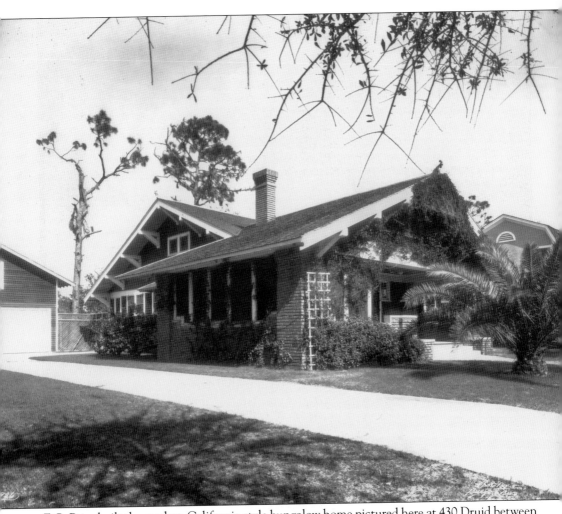

E.C. Price built the modest, California-style bungalow home pictured here at 430 Druid between 1914 and 1915. Note the expanded eaves and Alvord-style fascia treatment, which added depth to the facade of the home's conservative footprint. (Courtesy of Frank Hibbard.)

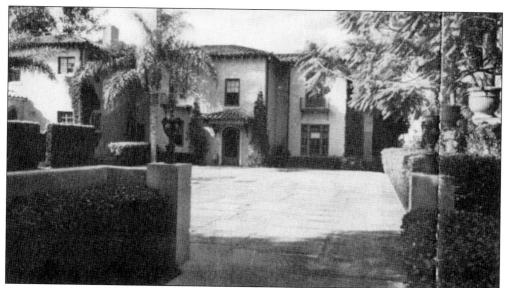

In this photograph, the vertical profile and manicured landscaping of the Harold Judd house on Druid Road South give it an estate feel. Spanish Mediterranean in design, the home majestically stands on a bluff overlooking Clearwater Harbor. (Courtesy of the Cooper family collection.)

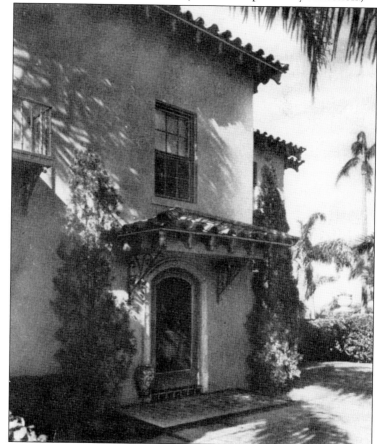

This photograph shows the front entry of the above noted house. Originally built in 1927 for Harold Judd, a stockbroker from Connecticut, the home's Spanish Mediterranean influences are clearly visible on the door's overhang and at the roofline. (Courtesy of the Cooper family collection.)

This photograph shows a plaque commemorating Fort Harrison, which began as a war fort in 1841 for the US Army and was said to be the catalyst for the founding of Clearwater as an agricultural port (with the arrival of the Peter Demens Railroad and establishment of Clearwater as the Pinellas County seat) by the 1850s. The plaque is located in front of the Kingsbury house at 800 Druid Road South, which is now part of the Century Oaks Estate. (Courtesy of Heritage Village.)

Here is an updated view of the Fort Harrison plaque. Five companies in the 6th United States Infantry (approximately 300 troops) built pine buildings here. Noted St. Petersburg College professor William Goza speculated that the decision made regarding the fort's location was based on the fact that the 6th Infantry was responsible for patrolling the coastline from Clearwater Bay to Homosassa Bay. (Courtesy of Heritage Village.)

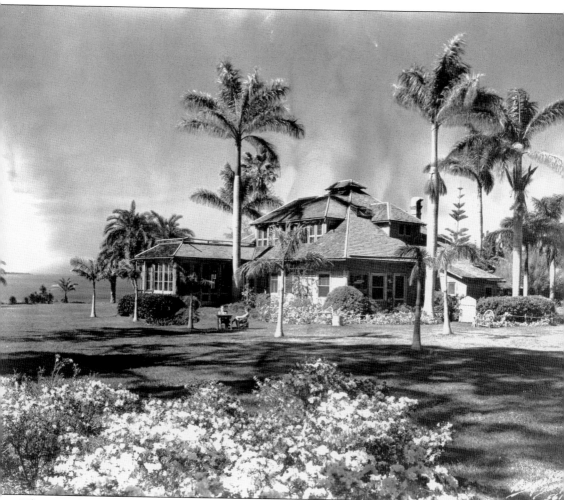

This is a photograph of Eagles Nest—the home Dean Alvord built for himself south of the Hotel Belleview overlooking Clearwater Bay. It was constructed following Alvord's move from Druid Road in Harbor Oaks and features a ventilated cupola and cypress siding. Classified by some architectural historians as a Bahamian style (because of the tapered high rooflines, which kept lower rooms cool in the days before air conditioning), this home complimented Alvord's reproduction of a Far Eastern garden. (Courtesy of the Harold Wallace Estate.)

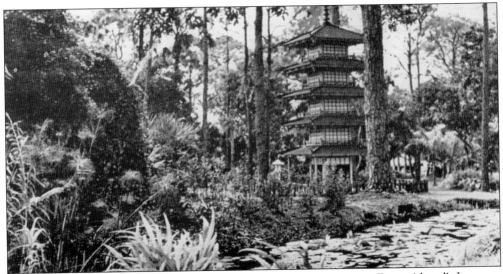

A dramatic view of what became a popular winter tourist attraction—Dean Alvord's Japanese Gardens, located on his Eagles Nest property—is captured here. The pagoda structure itself and the adjacent lily pond integrate nicely with the native Florida flora, which includes several sizable Southern Pine trees. In 1938, Alvord hired Fumio Hawakawa, a traditional Japanese-Hawaiian horticulturalist, to reproduce a Far Eastern garden. Hawakawa created a "Kawa-style" garden, which included references to mystic temples, Torii images, pagodas, and miniature bridges. This picture-style postcard (popular between the 1920s and 1940s) was sold at local Clearwater gift shops and dining establishments. (Courtesy of the Harold Wallace Estate.)

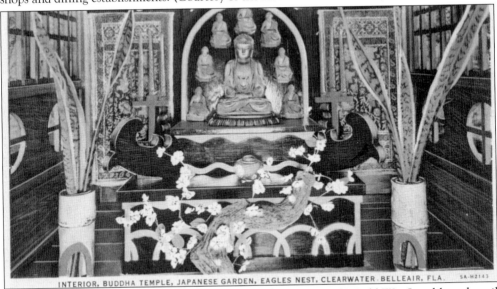

INTERIOR, BUDDHA TEMPLE, JAPANESE GARDEN, EAGLES NEST, CLEARWATER-BELLEAIR, FLA. SA-H2143

This postcard (from the classic framed-postcard era that followed World War I and lasted until the 1950s) features the interior of Dean Alvord's Eagles Nest and its Buddha Temple, with its teak inlays, carvings, and accent plants. Viewed by appointment only, the spot was a popular winter tourist attraction for many years up until the late 1940s. It is believed that a trip Dean and Donald Alvord made to the Far East in 1913 provided Dean an enduring inspiration for Japanese culture and gardening. Many of Harbor Oaks' streets have Japanese-influenced names. (Courtesy of Heritage Village.)

Here is the view of one of the pair of eagles crafted to flank the entrance of Dean Alvord's Eagles Nest. The garden park on the property was originally named Japanese Gardens following its construction, but this name was removed at the onset of World War II for patriotic reasons. The eagles were an inspiration to Alvord from former property owner John Dean, who had found a rare eagle's nest on the ground by one of the swamp oaks on the property and had climbed the tree to reposition it. The eagles later returned to nest. (Courtesy of Nancy Orth.)

Pictured here is the other eagle that graces the entrance of Dean Alvord's Eagles Nest. Many individuals toured the Japanese Gardens located on the home's property, and numerous postcard depictions of the area were also created. Scientists have determined that eagles build the largest birds' nests in the world, with some weighing more than 1,000 pounds. (Courtesy of Nancy Orth.)

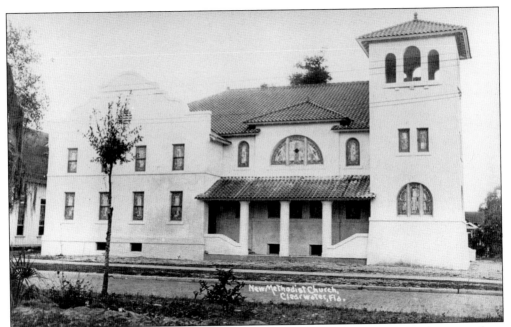

This photograph of the "new" United Methodist Church at 602 Fort Harrison Avenue is from 1921—the year the church was built. The congregation was started by Rev. Charles D. Nicholson in 1857, and this structure included many of the Spanish Mediterranean architectural elements also found in Harbor Oaks (such as a barrel-tile roof and a stucco facade). Unique gothic columns integrated into the dual entrances create an interesting stylistic contrast. (Courtesy of the Harold Wallace Estate.)

This sign, dated 1988, identifies Harbor Oaks as being listed in the National Register of Historic Places. The efforts of the Harbor Oaks' Homeowners' Association and the Clearwater Historical Society to obtain recognition and listing in the National Register began in the 1970s and were pursued in earnest in the 1980s. (Courtesy of Karl Scheblein.)

Five

HARBOR OAKS
PAST REFLECTIONS AND
FUTURE DIRECTIONS

While it can be said that Dean Alvord's Harbor Oaks remains one of the most notable and well-preserved estate housing developments on Florida's west coast, the significance of Alvord's community design and maintenance initiatives (such as plot configurations, street layout, community amenities, and use of deed restrictions to maintain community structural integrity and continuity) continue to have a nationwide impact on current housing development design, construction, and maintenance.

Thankfully, through foresight, planning, and the dedication of many current homeowners who recognize well-designed residential communities (and the historical value associated with such), Harbor Oaks is being preserved as one example of how high-quality residential housing can endure and prosper over time, particularly when governed by active homeowners' associations.

In this chapter, examples of how Harbor Oaks' homes looked when they were first developed and how those same homes look today provide an interesting glimpse into that successful recipe of creating outstanding design, identifying thoughtful function, and maintaining community beauty.

Is there still a significant pool of individuals like John Mohler Studebaker III or Charles Ebbets who have both the initial financial resources as well as sustainable financial coffers from which to draw the resources needed to maintain homes like the Studebaker/Dworkin house, the Judd/Cooper house, or others, at the condition levels demanded by both the initial developers and the owners themselves? Are there still developers like Dean Alvord in business today who play as important a role in community governance and advocacy (both within their developments and at the local/state government levels) as he did? How will the estate housing developments created on Florida's west coast since 1960 appear in contrast to Harbor Oaks when analyzed on the eve of their 100th anniversary of existence?

It is that final question that may serve as the basis for a future study of Florida's Harbor Oaks during its 100th-anniversary year and beyond while also determining whether the financial successes (both perceived and actual) of America's industrial complex—which Dean Alvord first capitalized on to create Harbor Oaks in Clearwater, Belle Terre on Long Island, and, to a lesser extent, Prospect Park South in Brooklyn—will exist in the future in the United States to enable wealthy residents who wish to reside in planned housing communities to do so. Only time and further analysis will yield an answer.

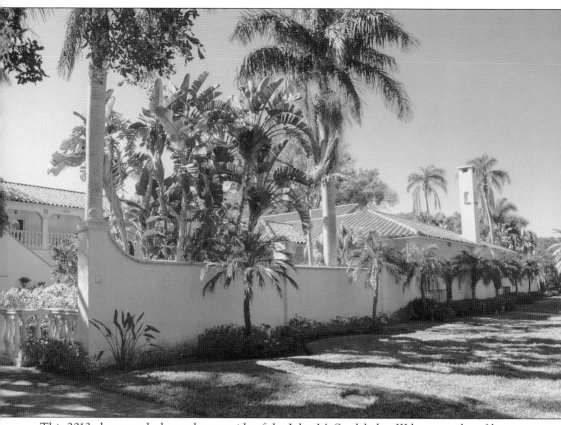

This 2013 photograph shows the east side of the John M. Studebaker III house and profiles some of the unique enhancements that have been added to the home, including a two-story guesthouse and panoramic dining area cantilevered over the swimming pool. Casual observers viewing the home from the front would not realize that the more expansive portion of the home exists to the rear. (Courtesy of Karl Scheblein.)

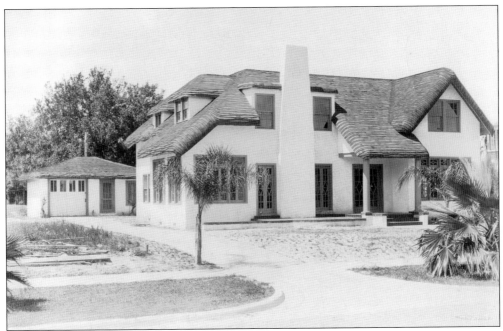

The English cottage–style W.D. Landers home has a unique wraparound–roof-shingle design that serves as the focal point. Flanked by double French doors, the fireplace is positioned within the front facade and may have two openings (one upstairs and one downstairs). Also notable in this design is the incorporation of a separate utility structure (or garage) located at the rear of the property. The photograph above was taken soon after the home's completion in 1926, and the one below was taken in 2013. (Above, courtesy of the Cooper family collection; below, courtesy of Karl Scheblein.)

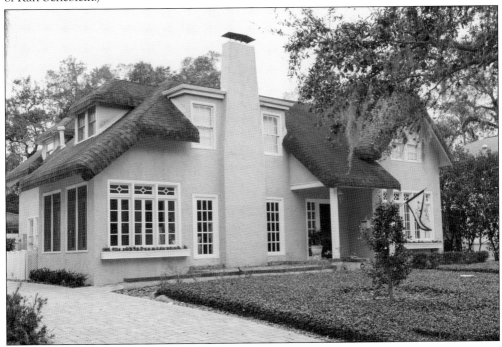

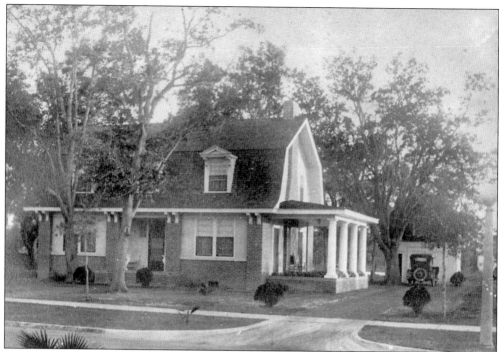

Here are two views of the home of successful Pinellas landowner Richard Randolph, a noted orange grower and local land developer. Pinellas realtor and Carlouel Yacht Club cofounder Paul Randolph (Richard's son) grew up here. Built in 1918, this excellent example of a Dutch Colonial is one of the few in existence on Florida's west coast. The home has been beautifully restored, and the western porch has been enclosed. (Above, courtesy of Michael L. Sanders; below, courtesy of Karl Scheblein.)

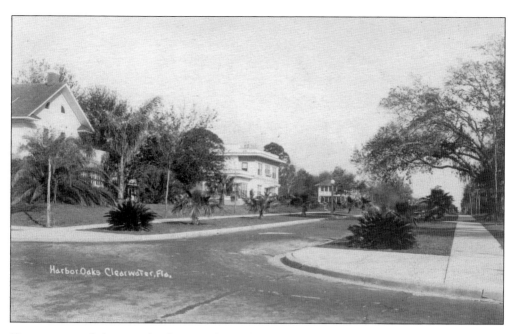

Here is a pair of photographs showing the Walter A. Bass house located at 308 Magnolia Drive both in the past (c. 1924) and in the present day. The above photograph shows the home on the left side of Magnolia Drive. This modified Colonial with uncommon architectural features was built in 1922 for Bass and his wife, Jane, who originally resided in New York City. The home features a side sunroom and deck. In the recent photograph below, note the property's elevation, formal front facade, and meticulous restoration. (Above, courtesy of Heritage Village; below, courtesy of Karl Scheblein.)

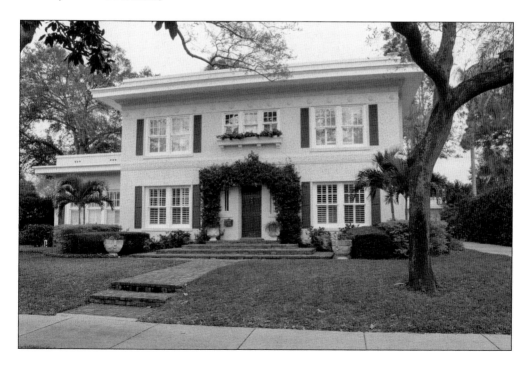

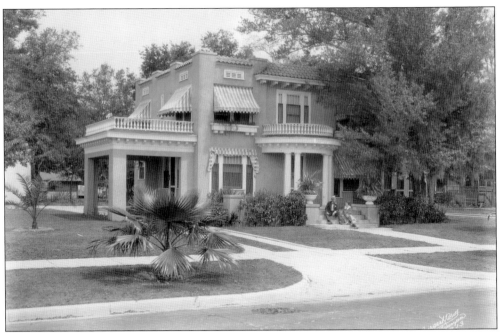

The modified Spanish Mediterranean–style home in these images was the residence of Mayor Frank J. Booth. It was originally designed and built by John Phillipoff for the mayor in 1923. Booth was a commercial realtor focused on the downtown area and served as mayor of Clearwater from 1920 to 1926. He was instrumental in fostering continued development in Clearwater even after the onset of the Great Depression. The present-day photograph below shows the home after it was faithfully restored by the Ruggie family. (Above, courtesy of the Ruggie family; below, courtesy of Karl Scheblein.)

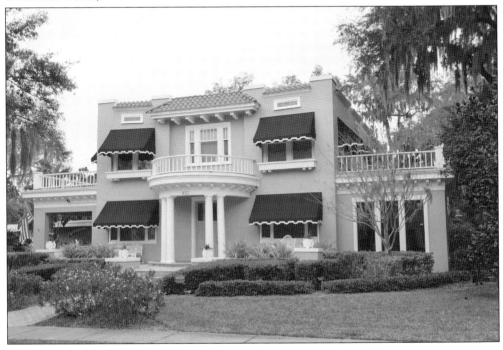

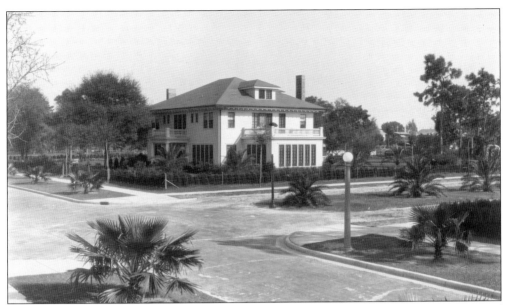

These interesting boulevard views (above, around 1920; below, in the present day) show one of the early estate homes in Harbor Oaks—the Harbison house—built in 1918 at 403 Magnolia. Evident is Alvord's ability to make landscapes and community infrastructure become the focal points of the development. Alvord had been one of the first to introduce the boulevard concept (the idea of incorporating a median with green space into a regular, double-sided street) in his Jamaica Queens and Long Island communities. This home has been expanded and updated several times, and for a short period, it housed convalescing troops at the end of World War II. Portions of the home's original grounds have been sold to three neighboring property owners. (Above, courtesy of the Tampa-Hillsborough County Public Library System—Burgert Bros. Collection; below, courtesy of Karl Scheblein.)

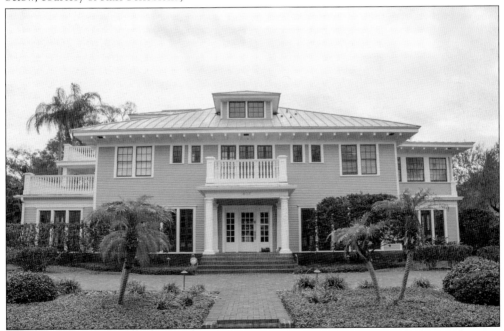

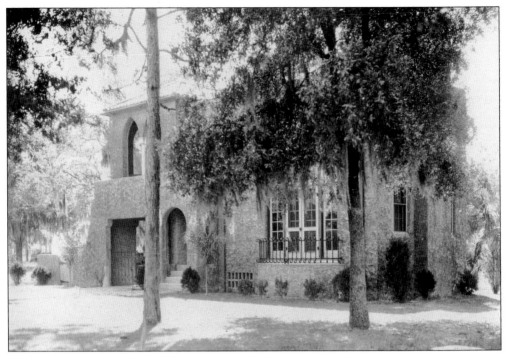

This Spanish Revival derivative named "Los Robles" (the Oaks) was built in 1925 for Raymond Brown, son of Robert S. Brown of Century Oaks. It features the traditional stucco facade but retains its origins in the use of arched windows above the carport. The arched entryway and faux balcony (with floor-to-ceiling French doors and dormer-style windows) also are unique design features. The home includes a fireplace (visible to the right), and gives a feeling of Mediterranean-style elegance in its use of native plants and trees. Today's view of Los Robles at 429 Magnolia Drive shows the home's graceful evolution amid the massive oaks and tropical landscaping. (Above, courtesy of the Cooper family collection; below, courtesy of Karl Scheblein.)

The really interesting aspect of these photographs is the contrast between the "old" that was once part of the Fort Harrison Orange Grove property and the "new" associated with the Harbor Oaks community. This home, known as the Coit house (featured above left in this c. 1927 photograph), was sold in 1929 after only two years of ownership by a financially stressed Charles Coit to wealthy neighbor Robert S. Brown, who then immediately sold it to realtor Paul Randolph for $350. It was Randolph's intent to live in this home, so he made the decision to relocate it from this original site to what is now 327 Lotus Path. Based on the overall design of the home and the existence of mature foliage and orange trees, it appears to be one of the early structures built on the bluff property soon after Alvord purchased the land in 1913 from E.H. Coachman. The photograph below of the home today shows that the Colonial Revival design has aged gracefully. Extensive, quality renovations have been made by the current owners over the past 20 years. One cannot appreciate it from this updated photograph, but when the home was moved by Randolph, it was curiously (but probably intentionally) positioned with its rear door facing the street. (Above, courtesy of the Tampa-Hillsborough County Public Library System—Burgert Bros. Collection; below, courtesy of Karl Scheblein.)

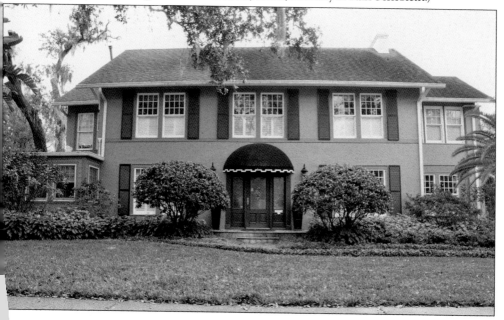

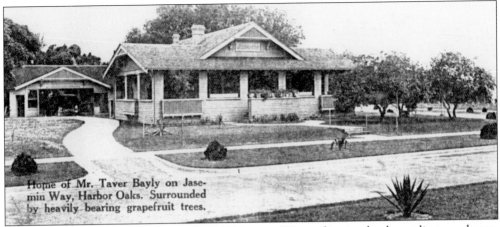

Home of Mr. Taver Bayly on Jasemin Way, Harbor Oaks. Surrounded by heavily bearing grapefruit trees.

The Bungalow-style home of Taver Bayly at 301 Jasmine Way and its simple, elegant lines are shown. This home was built with inherited funds at the mere age of 24 by citrus grower, Clearwater banker, entrepreneur, builder, and civic leader Taver Bayly in 1914. He rose to president of Clearwater's Peoples' Bank (which later became the First National Bank of Clearwater). This was only the third home built in Harbor Oaks. This house became a featured home in the 1916 Harbor Oaks sales brochure alongside larger, statelier properties—an ironic development as Donald Alvord related in a 1975 interview with Gyneth Stanley that he had to persuade his father, Dean, to allow this first bungalow to be constructed in Harbor Oaks. Apparently, Dean Alvord was not initially in favor of modest-sized homes being built in Harbor Oaks. Today's photograph below emphasizes the faux second story of the home's bungalow design, which Dean Alvord stipulated to be a required feature of the home following arguments with son Donald to allow construction of a bungalow-style homes in Harbor Oaks. This home is owned and has been honorably restored by Taver Bayly's granddaughter Sandy Jamieson, who sat on this porch in the evening as a young girl and listened to the bell tower concerts from the nearby Century Oaks campanile. (Above, courtesy of Frank Hibbard; below courtesy of Karl Scheblein.)

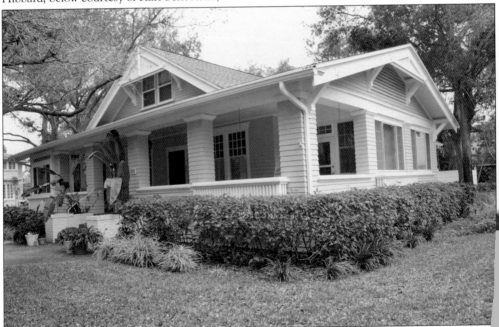

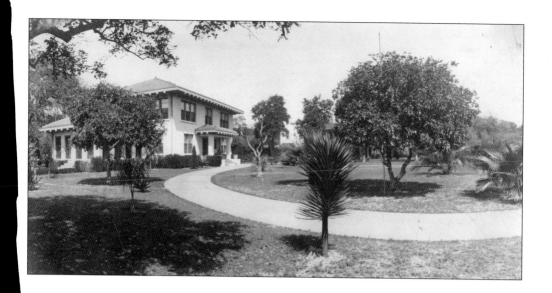

This is Century Oaks, built in 1914 by Dean Alvord and sold in 1922 to Robert S. Brown of Ford automobile paint fame. In the above c. early 1920s photograph, before the Brown era expansion, the home sits beneath massive oaks on a 23-foot-high bluff with its rear facing Clearwater Bay. Fruit trees, expansive grounds, and the Kingsbury home in the background can be seen. Today, the main house alone totals more than 23,000 square feet with the a high walled compound containing the north (Kingsbury) house and a south water's edge guest house amidst stunningly elaborate gardens, statuary, fountains, and pools. (Above, courtesy of Heritage Village; below, courtesy of JRS Photos.)

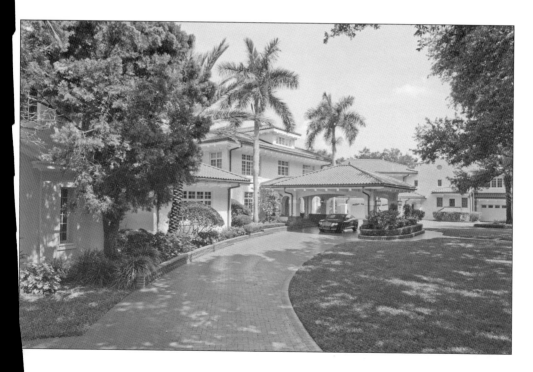

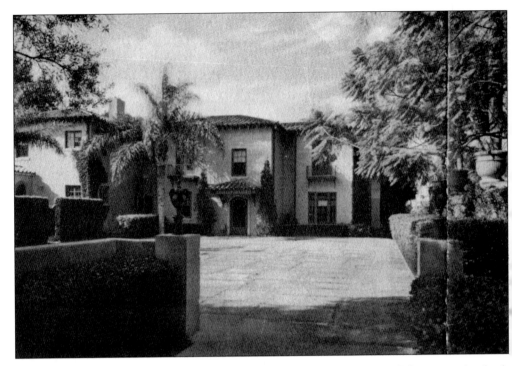

The Spanish Mediterranean feel of the c. 1927 Harold Judd home is beautifully captured in both the vintage and modern images pictured. The lattice eaves and barrel-tile roof complement the vertical lines of the home, pictured above, photographed soon after its completion, as does the park-like setting created by the current owners in today's view below. (Above, courtesy of the Cooper family collection; below courtesy of Karl Scheblein.)

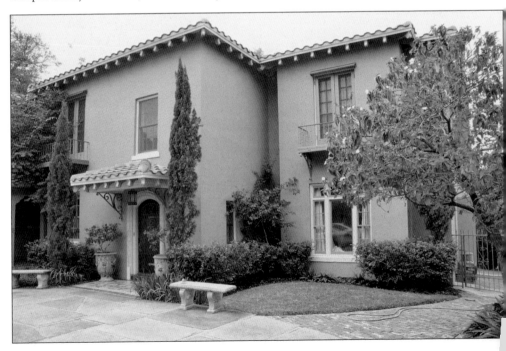

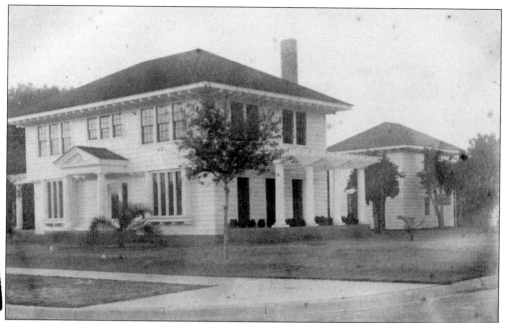

Originally built as a speculation home by Dean Alvord on land sold to him by his son Donald, this Colonial Revival home was designed by Lester Avery (Dean Alvord's chief architect and designer of many of the homes in Harbor Oaks and his New York–based properties). Built in 1918 and featuring traditional Gothic columns (as seen in this c. 1919 side view), it served as a home for the Alvords (Dean and his wife, Nellie), who resided there until selling the property to James and Jessie McAnulty of Lakawanna County, Pennsylvania, in 1920. Today's photograph below shows the lattice eaves and now-enclosed, trellis-like sunroom roof in full view. (Above, courtesy of Cooper family collection; below, courtesy of Karl Scheblein.)

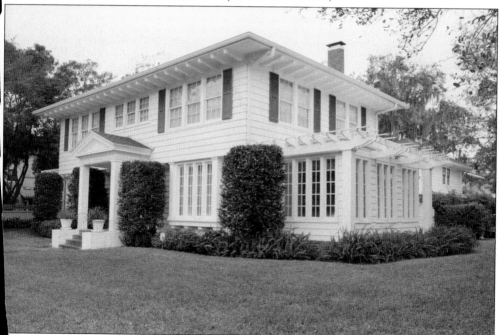

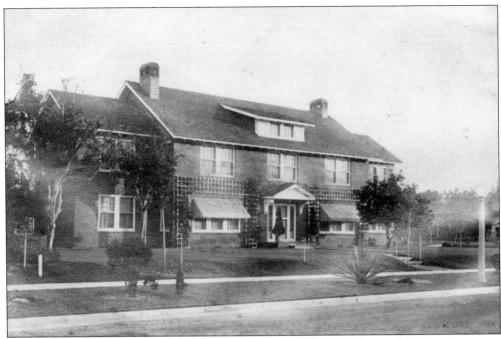

The vintage shot of author Sewell Ford's home (above) provides a clear view of the home's cottage-like properties, including the latticework that adorns the front facade. Ford was a charismatic writer whose childhood ambition was to be a smuggler. When he realized a life of espionage would not be a positive pursuit, he directed those ambitions to his writings. Today's view (below) shows the richly landscaped property's characteristic elevation and the second-story dormer above the entrance. This home has undergone extensive physical renovation and is magnificently maintained. (Above, courtesy of Michael L. Sanders; below, courtesy of Karl Scheblein.)

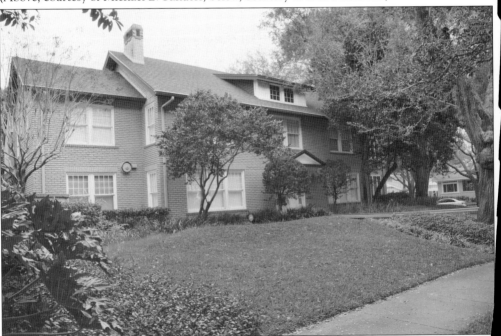

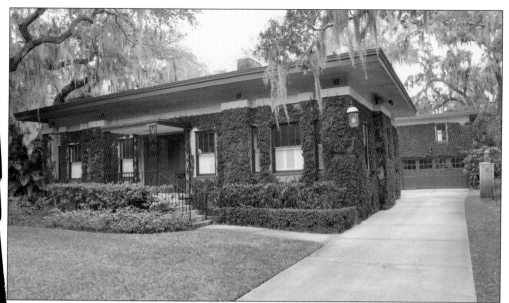

This home at 421 Druid Road West was built in 1918 for Dr. John Bowen. Henry Plant II, son of Morton F. Plant and grandson of Henry Plant, was injured while visiting Clearwater in 1912. Because there was no hospital, a medical railcar from Chicago was brought to the Hotel Belleview so the boy could convalesce. With Doctor Bowen's urging, Morton Plant agreed to create a $100,000 hospital endowment if the community could raise $20,000. Morton Plant Hospital opened in January 1916. (Courtesy of Karl Scheblein.)

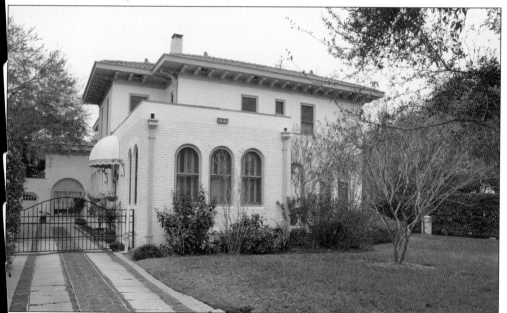

This 301 Druid West structure was built in 1922 by Charles Ebbets, who moved the Brooklyn Dodgers' spring training to Clearwater in 1923. The home originally had a redbrick facade. Ebbets developed a heart condition soon after the completion of the home and died in New York in 1925. Charles H. Ebbets Jr. owned the home until his death in 1944. Soon thereafter, the team's spring training site moved, and the home was sold. (Courtesy of Karl Scheblein.)

DISCOVER THOUSANDS OF LOCAL HISTORY BOOKS
FEATURING MILLIONS OF VINTAGE IMAGES

Arcadia Publishing, the leading local history publisher in the United States, is committed to making history accessible and meaningful through publishing books that celebrate and preserve the heritage of America's people and places.

Find more books like this at
www.arcadiapublishing.com

Search for your hometown history, your old stomping grounds, and even your favorite sports team.